IMAGES
of America

EARLY PASADENA

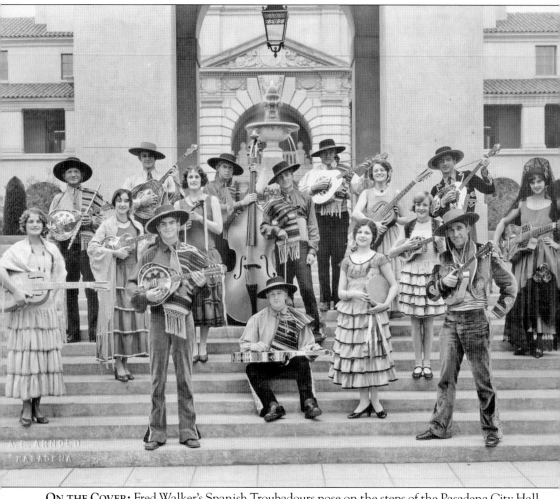

ON THE COVER: Fred Walker's Spanish Troubadours pose on the steps of the Pasadena City Hall for an official group photograph in 1929. The Spanish Troubadours were headquartered out of Walker's home at 2254 Casa Grande Street. During the day, Fred Walker taught at John Marshall Junior High School. (Photograph by A. E. Arnold.)

IMAGES
of America

EARLY PASADENA

Cedar Imboden Phillips and
the Pasadena Museum of History

ARCADIA
PUBLISHING

Published by Arcadia Publishing
Charleston SC, Chicago IL, Portsmouth NH, San Francisco CA

Printed in the United States of America

Library of Congress Catalog Card Number: 2007943439

For all general information contact Arcadia Publishing at:
Telephone 843-853-2070
Fax 843-853-0044
E-mail sales@arcadiapublishing.com
For customer service and orders:
Toll-Free 1-888-313-2665

Visit us on the Internet at www.arcadiapublishing.com

*To the volunteers, staff, trustees, and members of the
Pasadena Museum of History, past and present*

CONTENTS

ACKNOWLEDGMENTS

This book would not have been possible without the help and encouragement of many people. Special thanks are owed to Jeannette O'Malley, executive director of the Pasadena Museum of History, for her support of this project and for her tireless work on behalf of the museum and its mission. Another large thank-you goes to the museum's dedicated staff members and volunteers. Their work cannot be overstated; they are the ones helping to preserve Pasadena's rich history for the benefit of current and future generations. One need only visit the library and archives on a busy day to see firsthand the dedication of these important stewards of local history and culture. Thanks are also in order for Jerry Roberts, my editor at Arcadia Publishing, who helped craft this project from start to finish. Finally, I would like to give special thanks to my husband, Andrew, and son, Jackson, for their love and support.

If the photographer, studio, or personal collection for a particular image is known, credit is attached to the caption. All photographs appear courtesy of the Pasadena Museum of History.

INTRODUCTION

Pasadena's earliest known history dates back to the 1700s, when the Gabrielino Indians lived along the Arroyo Seco and in mountain canyons in the Pasadena area. Many of the Gabrielinos converted to Christianity following the arrival of Spanish missionaries in 1771 and the subsequent founding of the San Gabriel Mission.

Another chapter in Pasadena history occurred when the land transferred from Spanish to Mexican rule. The area that would become Pasadena was part of a larger rancho and eventually came to be owned by Col. Manuel Garfias. In 1859, the land—by this point part of the United States—transferred yet again, this time into the hands of John Griffin and Benjamin "Don Benito" Wilson. During the 1860s, the land remained rural, with the primary agricultural industry the growing of Muscat grapes.

In 1873, a group of men and women from Indiana came to Pasadena following a particularly unpleasant winter. They purchased land in Pasadena with the intent of starting an agricultural community. After a rough start, the members of the Indiana Colony started growing citrus trees and other crops. These settlers came up with the name *Pasadena*, a rough interpretation of a Chippewa Indian word for "Crown of the Valley." These men and women are generally considered the pioneers of Pasadena.

The 1880s were pivotal years for Pasadena, during which it began the transformation from small agricultural community to full-fledged town. One important event occurred in 1886, when Pasadena formally incorporated as a city. This action was driven primarily by a desire to enact restrictive liquor laws and to rid the town of its saloon. The years before and after 1886 were marked with frantic development and speculation, leading to the building of a commercial district centered around the Colorado Street and Fair Oaks Avenue intersection. The town suffered a setback in the late 1880s when the real estate market collapsed, but development picked up again—this time at a more reasonable rate—during the next decade.

In 1890, the Valley Hunt Club launched what would become Pasadena's biggest and most famous event. A winter parade of floral-covered buggies and carriages highlighted Pasadena's attractive climate. The parade and associated events grew in popularity, eventually solidifying into a parade and a football game organized by the Tournament of Roses.

The 1890s and early 1900s brought increasing numbers of tourists, many of them coming to Pasadena to better their health and to escape cold and snowy winters. After a winter spent in "America's Paradise," many of these visitors came back the following year as permanent residents. The city grew quickly as more and more people learned about the city and its offerings. The resort hotels grew as well, providing hundreds of rooms for visitors who wanted to winter in the city. These hotels—the Hotel Green, the Hotel Vista del Arroyo, the Hotel Maryland, and the Hotel Raymond (in adjacent South Pasadena)—acted as both the center of the service-based economy and the center of the town's social life.

The early years of the 20th century were important for Pasadena's scholarly life as well. Local elementary schools thrived, and free kindergartens were formed across the city. Throop University was founded, later to become the California Institute of Technology (Caltech).

Culture was an important component of Pasadena life. One of the country's earliest and most significant community theater groups, the Pasadena Community Playhouse, was established in 1917. The public library thrived. Art shows and musical concerts were offered on a regular basis. Pasadenans were proud of their culture and wanted to prove that their city could rival the cities "back east."

Tourism continued as an important aspect of Pasadena life in the second decade of the 20th century, gaining an extra boost during World War I when wealthy Americans could no longer spend their winters traveling in Europe. Tourists visited the mountains, hiked local trails, and took "tally-hos" to nearby attractions such as the San Gabriel Mission, the poppy fields of Altadena, and Cawston's Ostrich Farm.

The 1920s are considered by many to be the golden age in Pasadena, a time when many of the city's architectural masterpieces—including the iconic city hall—were planned and constructed. A highly planned civic district grew around city hall, while development in general moved eastward along Colorado Street. The Rose Bowl was built at this time, along with other facilities in Brookside Park. Many new residential neighborhoods grew during this period as well, providing homes for the city's many middle-class residents.

The 1930s were difficult years for Pasadena, as they were for the rest of the country. Fewer tourists meant the closing of many of the city's great hotels and tourist attractions, as well as fewer customers for the shops and services. By the end of the decade, the city was starting to develop a reputation as a light manufacturing and crafts center. The number of industrial-related businesses was now climbing after the sharp drop at the beginning of the decade. Printing had become Pasadena's premier industry.

All of the photographs in this book come from the collections of the Pasadena Museum of History, the perfect place to begin an exploration of the city's history. The fascinating story of early Pasadena is too complex and extensive to be adequately told in just one book; consider this an introduction to the topic and an invitation to learn more about the city's exciting past.

One

A City Is Born
1860–1890

Pasadena's modern history begins in 1859 when John Griffin and Benjamin "Don Benito" Wilson purchased a large land grant from Mexican colonel Manuel Garfias. Griffin and Wilson then subdivided their land, selling plots to other newcomers. These early settlers began what would become Pasadena's major agricultural industry: the cultivation of citrus and grapes.

Settlers comprising the California Colony of Indiana planned to move to the area to develop an agricultural economy based on citrus. That group disbanded because of economic problems, leaving the remaining members to organize in November 1873 as the San Gabriel Orange Grove Association. The association purchased 4,000 acres of land, called it the Indiana Colony, and set about growing citrus trees. In 1876, members shipped their first carload of oranges east.

The 1880s marked Pasadena's shift from small agricultural community to expanding town. Within this decade, many civic institutions and churches constructed permanent buildings (many to be replaced later), and the Colorado Street business corridor was developed. Pasadena officially incorporated as a city in 1886. One of the leading factors for incorporation was alcohol, or rather the ability to legislate against it. A large and active temperance movement was eager to rid the city of saloons.

The 1880s also marked the beginning of tourism to the city. Two early hotels were established, along with the train connections that would make it possible for Eastern tourists to easily travel to Pasadena. This decade set the stage for what would soon become one of the city's biggest industries.

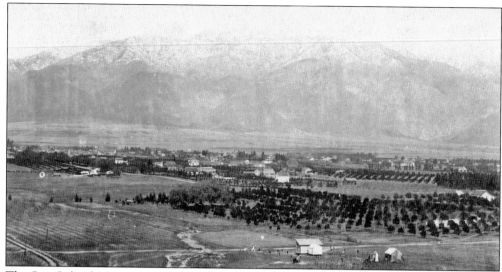

The San Gabriel Mountains rise up behind Pasadena, while citrus groves line the land below. This view was taken from the Hotel Raymond, one of the area's grand resort hotels, in the spring of 1887. At the time, the Raymond was still officially part of Pasadena. By the following year, however, the land under the hotel was in South Pasadena. (Photograph by Jarvis.)

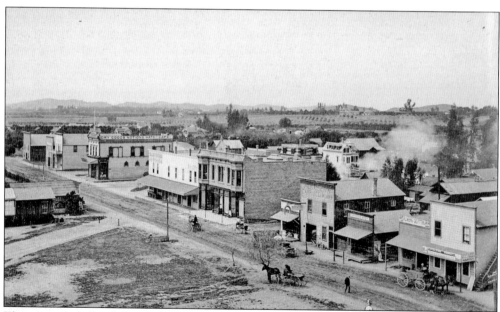

The stores along South Fair Oaks Avenue, pictured here, served the needs of the small agricultural town. Businesses included the Pasadena Carriage Works and Blacksmith, recognizable by the large horseshoe hanging outside its entrance, a plumbing store, a clothing shop, a bakery, and a dry goods store. (Photograph by E. S. Frost and Son.)

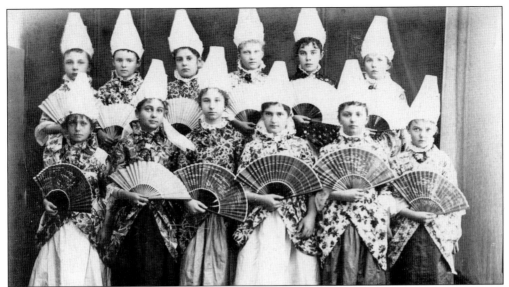

The Fan Drill Brigade, shown in 1883, was a group of young women who performed elaborate dances, enhanced with the artistic fluttering of fans, at various Pasadena philanthropic events. In November 1886, for example, the Brigade headlined an evening's entertainment to benefit the public library. They were described in the *Pasadena Star* as "graceful dames and damsels" who "glided down the aisle to the stage with the steps of the stately minuet."

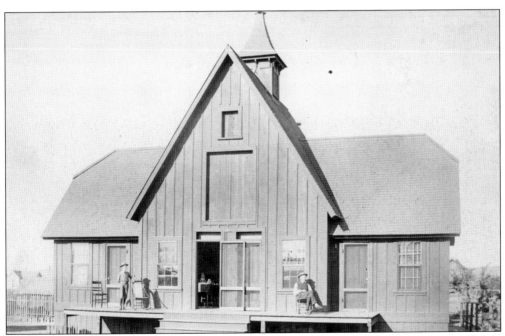

Not all of Pasadena's residents lived in grand homes. Built as a barn, this structure served as a residence for the Vernminter family sometime around 1880. It was common during the 1880s for new arrivals to spend time living in their barns before constructing permanent houses.

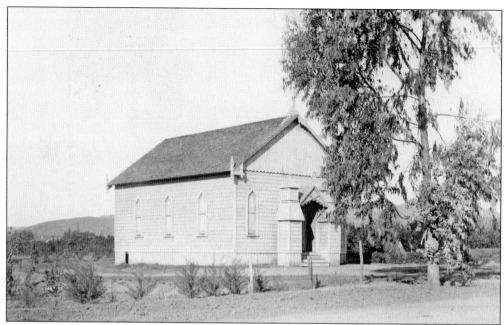

This humble wood building was Pasadena's original First Methodist Church. During the initial years of the Indiana Colony, Methodists and Presbyterians held joint services, as both denominations had so few parishioners. The groups parted ways in 1875, and two years later, the Methodists dedicated this church, on South Orange Grove Avenue near Palmetto Drive.

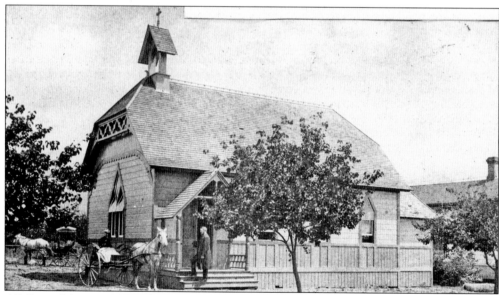

All Saints Mission, pictured in 1885, was the first Episcopal church in Pasadena. The church was originally located at Colorado Street and Garfield Avenue in a building accommodating 125 people. The first service was held on Easter 1885. Here Rev. A. W. McNabb stands on the steps of the newly constructed church, while Mrs. McNabb sits in the cart.

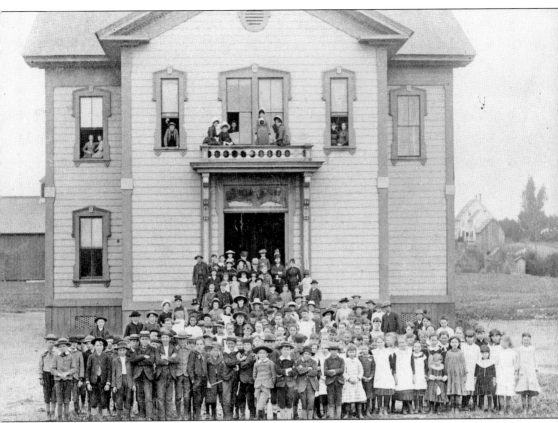

Students pose outside Pasadena's Central School. By the late 1870s, the student population had outgrown the small one-room schoolhouse that was being used. A bond issue for $3,500 was passed, and local residents took up the task of raising the additional funds. Nearly everyone in the colony gave money, goods, or services, and the result was this two-story frame building, named the Central School and first used in 1879. The upstairs room served as a community meeting place until Barney Williams built his store and hall. During the facility's first year, approximately 40 students from 30 families attended. By 1883, the average attendance was 100, causing severe overcrowding. A year later, that number had grown even higher, with 155 students attending on a daily basis. In 1886, the trustees agreed to sell Central School and use to the proceeds to build a larger school in a different location. The five-acre lot commanded $44,772 at auction. (Photograph by E. S. Frost and Son.)

Old Fair Oaks Road was a dusty country path when it was photographed in 1888. Visible in the distance are the homes of Levi and Luna Giddings (left) and their son-in-law Calvin Hartwell, both with addresses on Summit Avenue. Old Fair Oaks Road later had a name change to differentiate it from Fair Oaks Avenue; the street, no longer dusty or quiet, is now known as Lincoln Avenue.

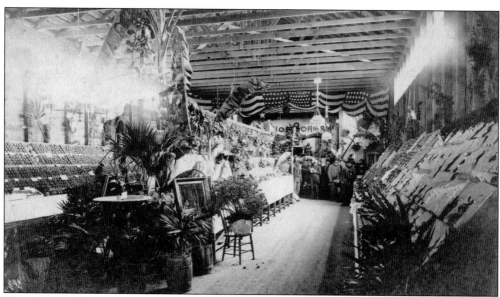

This photograph possibly depicts the Pasadena Fruit Association's citrus fair of March 24, 1880, the first in the area. The second Pasadena citrus fair was held in 1885, although an earlier regional one had been sponsored by the Southern California Horticulturalist Society in 1881. (Photograph by T. G. Norton.)

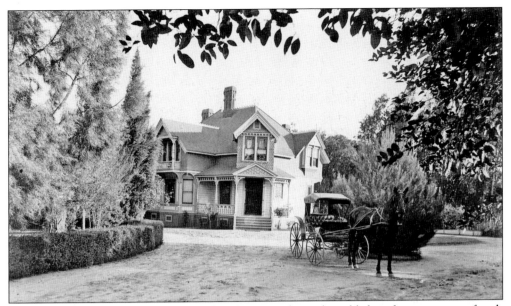

"Every house is surrounded [by flowers] and one needs not be told that the occupants of such homes as these are refined and cultivated people," wrote Clara Spaulding Brian of Pasadena in 1883. The Conger family, residents of this Pasadena house, might have agreed with that statement. Shown around 1886, the home was situated near Colorado Street and Orange Grove Boulevard. Dr. E. L. Conger was a prominent figure in early society.

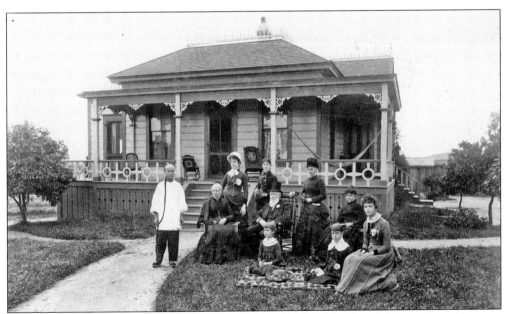

Chinese men lived in Pasadena while working in the town's fields, households, and laundries or as independent peddlers of vegetables. Many had come to the country to work on the Central Pacific Railroad and then remained following its completion. A Chinese man, presumably a servant, is included in a Pasadena family's formal portrait. (Photograph by E. S. Frost and Son.)

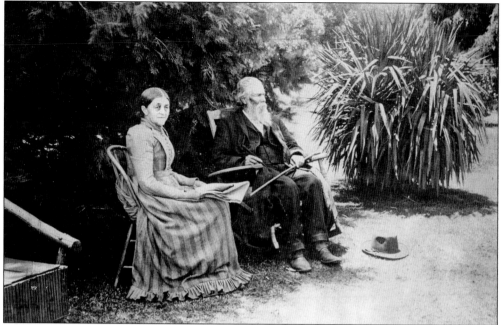

In 1876, scholars Ezra and Jeanne Carr purchased their Pasadena land, located by Colorado Street and Orange Grove Boulevard. There they lived in a small log cabin on an estate they called Carmelita. Their home, hidden from the road by lush foliage, was designed to showcase botanical finds from around the world. Among other endeavors, Jeanne Carr raised mulberry trees and attempted to start an American silk industry. (Photograph by Lamson.)

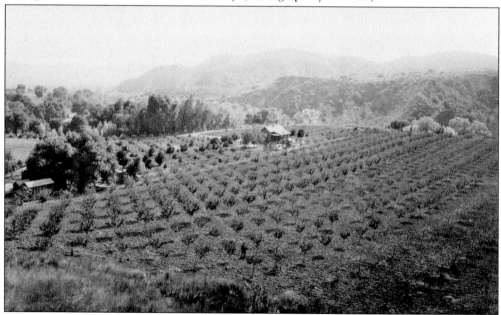

This orchard, photographed in 1889, grew in the Arroyo Seco below what is now Colorado Boulevard. In 1886, an advertisement for the Pasadena Land Company gave a reason for Pasadena's success: "It has the sum total of all earthly excellencies: a perfect climate, unsurpassed scenery, an enterprising and intelligent people." (Photograph by Taber.)

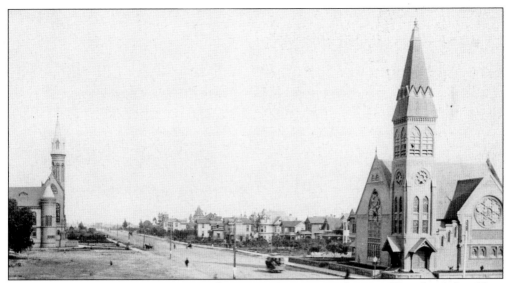

The intersection of Colorado Street and Marengo Avenue was the site of Pasadena's first blaze fought with the aid of a fire truck. Following much excitement, the truck arrived in 1889, and a test fire was set in this intersection. The engine extinguished the flames and then celebrated by shooting a stream of water over the steeple of the Methodist Episcopal church (right).

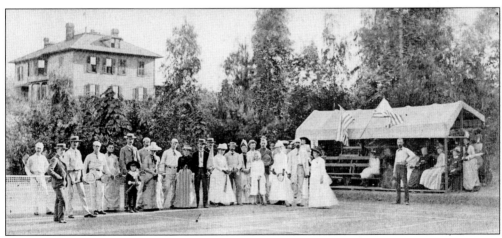

Tennis was a popular sport for both men and women in the late 19th century. Here Pasadena tennis players pose at the Channing court in 1887. The Channing home and tennis court was located near the corner of Orange Grove Boulevard and Walnut Street, where the Pasadena Museum of History now stands. (Photograph by Lamson.)

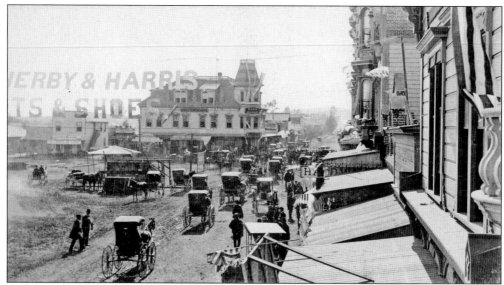

By the early 1880s, Pasadena's commercial district revolved around the Colorado Street and Fair Oaks Avenue intersection, a spot that was, in the words of an 1883 *Pasadena Chronicle* article, "one of the best for business in the colony, being central and about midway between Orange Grove Boulevard and Marengo Avenue, both of these streets overlooking the valley and the growing town."

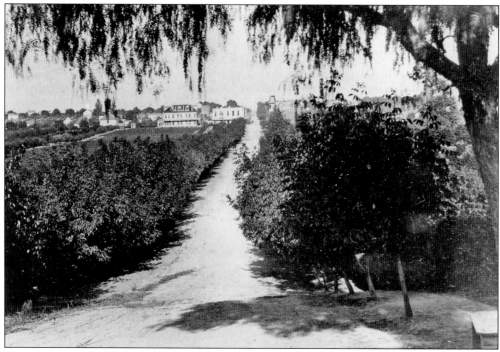

Dating to the early 1880s, this view captures the essence of early Pasadena. It was taken from the hill east of where Orange Grove Boulevard and Colorado Avenue now cross. In the distance is Pasadena's downtown, separated from the photographer by orderly orchards. The building with the tower is the Ward Block, located at the intersection of Colorado Street and Fair Oaks Avenue.

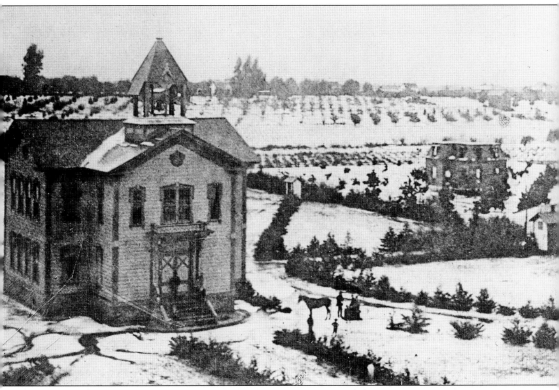

The summer of 1885 has a record-setting place in Pasadena's weather history. On June 13, residents were surprised with an hour-long storm consisting of snow, rain, and hail. It was a familiar, if unexpected, sight for those with Midwestern and Eastern roots. People attempted to find sleds and sleighs, or a least materials that would make an appropriate substitute, and the town was soon filled with snowballs, snowmen, and winter sports. A good time was reportedly had by all. Shown here is the white-covered ground around Central School, at the corner of Fair Oaks Avenue and Colorado Street. Residents enjoyed several hours of wet snow before it melted away, leaving an indelible mark in the city's collective memory.

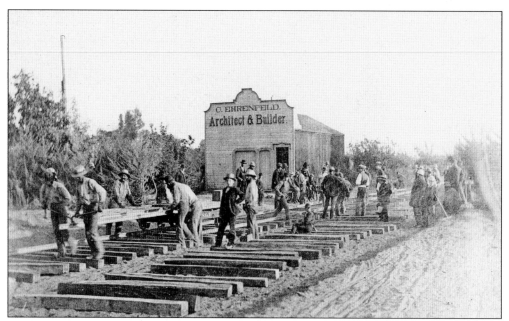

Workers lay track for the San Gabriel Valley Railroad at the Colorado Street crossing. The railroad was operational by September 1885, linking Pasadena with the rest of the county and country. Rail connections provided a boost to the local agricultural economy and to the fledgling tourism industry.

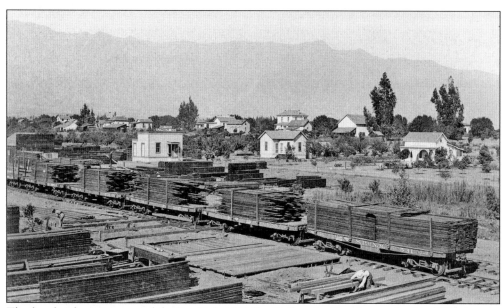

The first freight train to travel the San Gabriel Valley Railroad to Pasadena arrived in 1885. Among other things, it carried carloads of lumber destined for the Pasadena Lumber Company. This cargo was likely destined for the many new houses and commercial buildings under construction in the area. (Photograph by E. S. Frost and Son.)

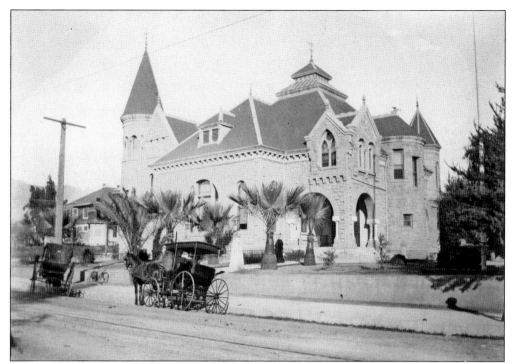

"Give us the money, fellow citizens," entreated the Pasadena Public Library trustees in 1886, "and we will do our best to prove by the erection of a permanent, beautiful, well planned and well filled library that Pasadena is what it claims to be in point of culture and refinement." Residents opened their wallets, and the eventual result was the construction of this impressive building at Raymond Avenue and Walnut Street.

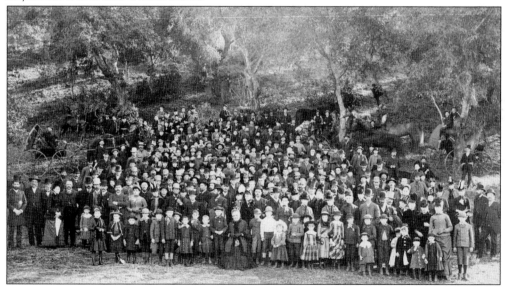

This January 2, 1888, picnic brought together the city's Iowa natives. Similar picnics were held across the region for those from other Midwestern states. The tradition tapered off as more of the city's younger residents—perhaps some of the children seen here—grew up and lost touch of their Midwestern roots. (Photograph by Jarvis.)

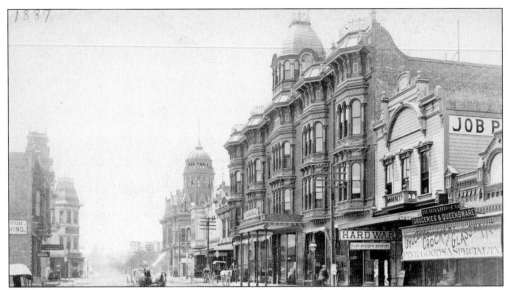

Taken on Colorado Street, this view looks toward Fair Oaks Avenue in 1887. Residents would come here for shopping, community gatherings, or entertainment. Despite Pasadena's relatively small population, this densely compacted commercial district had the excitement and activity found in much-larger cities. Colorado Street was frequently filled with horses, buggies, wagons, and pedestrians, along with horse-drawn streetcars in the late 1880s.

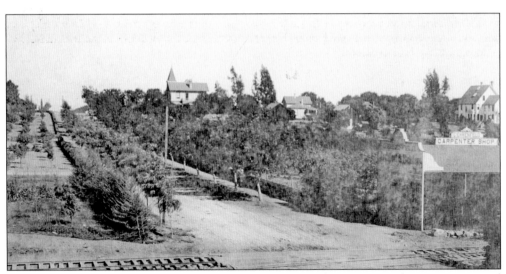

This c. 1885 view looks east on Colorado Street from Raymond Avenue. Development progressed quickly in Pasadena during the 1880s. "In and about Pasadena one sees new houses on every side that spring up as if it were by magic," wrote a *Pasadena Chronicle* reporter in 1883.

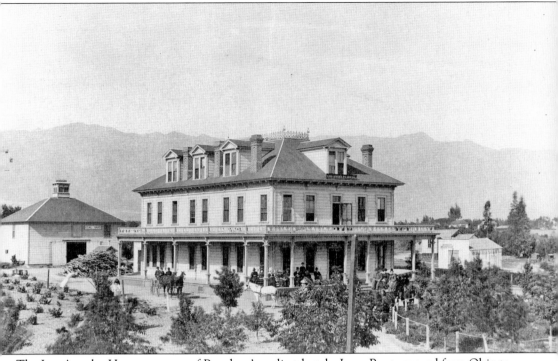

The Los Angeles House was one of Pasadena's earliest hotels. Isaac Banta moved from Ohio to Pasadena like so many others and purchased a small hotel he named the Lake Vineyard House. It was situated in an orange grove on South Marengo Avenue—a beautiful setting, but one too far from the town center to be practical. In 1883, Banta bought property on the northwest corner of Fair Oaks Avenue and Colorado Street and promptly set about constructing this building. Bigger and grander than what was needed, the hotel can be seen in hindsight as a harbinger of what was to come. Around the same time as the Los Angeles House's construction, T. E. Martin purchased a lot on the southwest corner of the same intersection, where he built the Martin Block. He rented the property to E. C. Webster for use as a hotel, creating a Pasadena hotel hub and contributing to the quick growth of the town's business district during the mid-1880s. (Photograph by T. G. Norton.)

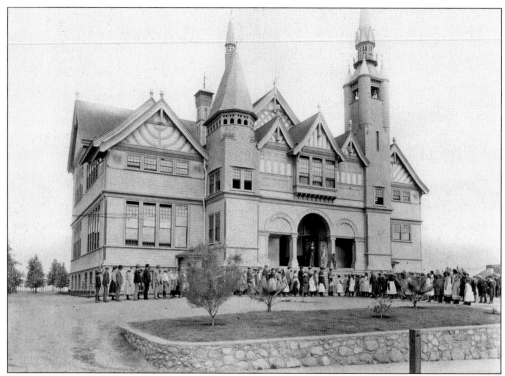

The James A. Garfield Elementary School opened in 1888. Pasadena's population had exploded during the late 1880s, and many new facilities were needed to handle the large number of students. Like many Pasadena schools, Garfield called several buildings home over the years. (Photograph by J. B. Blanchard.)

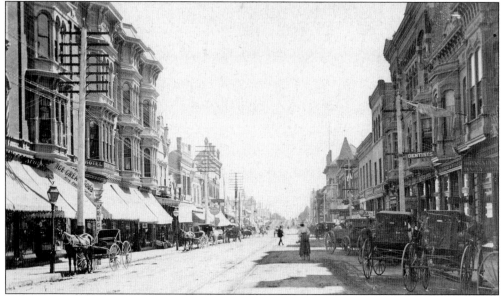

This 1887 view, taken from Fair Oaks Avenue, looks east along Colorado Street. The road was lined with shops and restaurants, and parking could at times be an issue. In the 1880s, parking was still a matter of finding a place to leave one's horse and carriage. (Photograph by Kohler.)

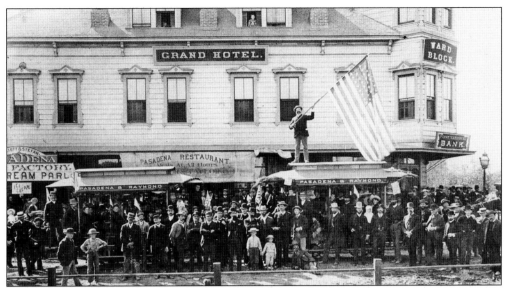

Pasadena residents celebrate the 1886 launching of the town's first horse-driven streetcars. The streetcar experience in early Pasadena could be quite informal and relaxed at times; the drivers would often make deliveries on behalf of local businesses, wait patiently for a rider if needed, and help bind the community together in ways extending beyond just transit.

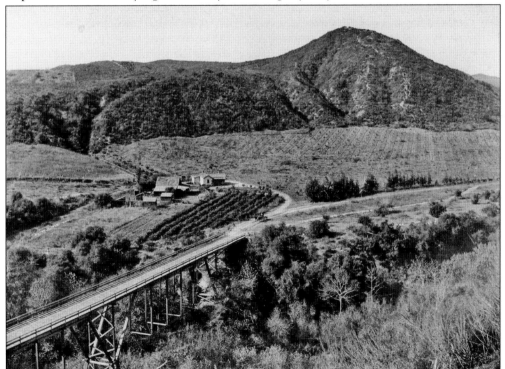

The West Pasadena Railway's streetcar line connected residents of the Linda Vista area with downtown Pasadena. To get to Linda Vista, the cars traversed this bridge, located at Linda Vista Avenue and Holly Street. Pictured in 1887, the bridge measured 18 feet wide and 380 feet long and hovered 80 feet above the ground. (Photograph by C. McMurtrey.)

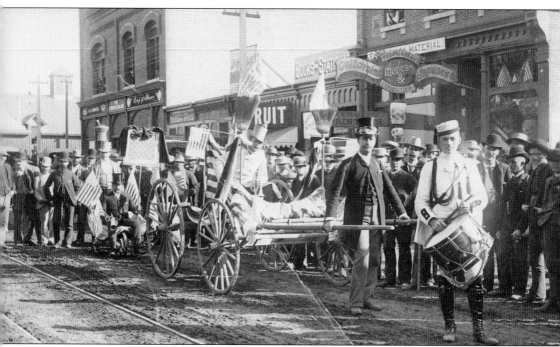

Pasadena was Republican territory in 1888, so it was no surprise that after the 1888 election, several local Democrats lost election bets with their Republican friends. The result was the parade shown here, a procession that wound its way up Colorado Street, Fair Oaks Avenue, and Raymond Avenue. George Frost (far right) led the parade, followed by Democrat J. S. French of the Kerckhoff-Cuzner Lumberyard drawing Republican R. A. Johnson in a wagon decorated and festooned with brooms. Behind them was W. O. Bellaire, a Democrat and owner of the Brunswick Billiard Hall, leading Republican W. B. Parker in a wheelbarrow. The procession was further enlivened by the Republicans' cheerful hooting of horns. Later that evening, local Republicans gathered to officially ratify the election results. Other celebrations included a grand party at the home of George Kernaghan near Olcott Place and Orange Grove Avenue; he hired the Pasadena Band for the evening and planned to listen to patriotic songs interspersed with fireworks. (Photograph by Jarvis.)

Two

PASADENA MATURES
1890–1900

During the 1890s, many of Pasadena's wealthy tourists began to put down roots, building houses along Orange Grove Avenue, a street later known as "Millionaire's Row." These residents came to Pasadena for the sunny climate; not only was it enjoyable, but it was believed to have healthful properties. Private hospitals as well as in-home nurses cared for people with tuberculosis and other problems. Pasadena's natural attributes were a boon to tourists and residents alike. The nearby mountains, just several miles from downtown Pasadena, were a popular destination, as were hikes through the Arroyo Seco.

The decade also brought the start of what would become one of Pasadena's chief claims to fame: the Tournament of Roses. The Valley Hunt Club launched the first parade in 1890 with the intent of highlighting Pasadena's balmy climate. The parade was followed by games in a nearby park.

Grand resort hotels were built to house trains filled with visitors from the Midwest and East. The newly formed board of trade advertised Pasadena's natural beauty and balmy weather nationally, sending out packets to interested visitors showing men and women picking oranges in January. The city was portrayed as "America's Paradise," and indeed for many, it lived up to its promises.

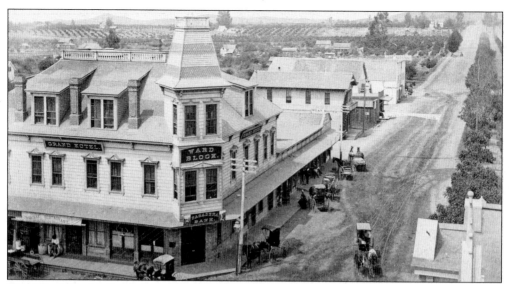

The Ward Block's hotel, located on the southwest corner of Colorado Street and Fair Oaks Avenue, originally opened as the Webster Hotel in 1884. It became the Grand Hotel after the property was purchased by Edwin Ward, who bought the building in 1886 at a cost of $17,000. This photograph was taken while the business was under Ward's ownership. (Photograph by E. S. Frost and Son.)

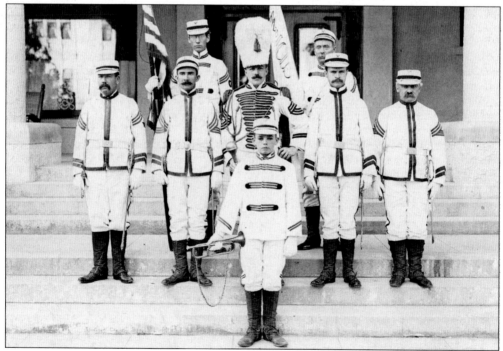

"In 1896 the enthusiastic young men—and many old men who never knew they were old—of Pasadena concluded that it was possible to have a marching club in the 'Crown City of the Valley' that should bear its banner before any and all comers," read an 1899 Americus Club newspaper. Some of those old and young men pose in this official Americus photograph. (Photograph by Pierce.)

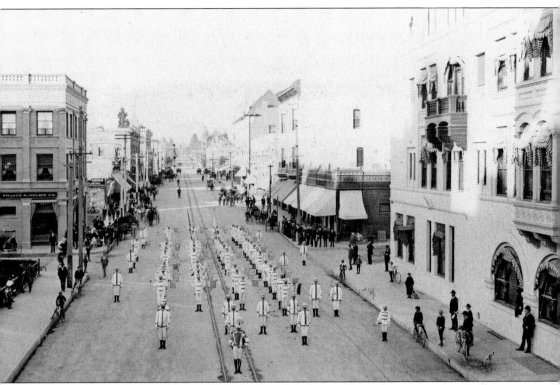

J. W. Wood, an active and enthusiastic member of the Americus Club, proclaimed, "It is my most confident belief that this club saved the state for the Republican party in 1896," doing so by instilling patriotism and enthusiasm in previously apathetic voters. He claimed there was a widespread demand for the services of "fine looking, well drilled" men in cities across the region. In addition to completing drilling exercises, Americus Club participants met socially. Wood's book, written more than 10 years after the group dissolved, gives a flavor of the sensibilities of its members: "Brothers in arms, once again, I salute thee—A-M-E-R-I-C-U-S!" Here some of the 200 to 300 members of the Americus Club show off their marching and drilling skills in a Pasadena parade held on January 9, 1899. The photograph was taken on Raymond Avenue just south of Green Street. (Photograph by Pierce.)

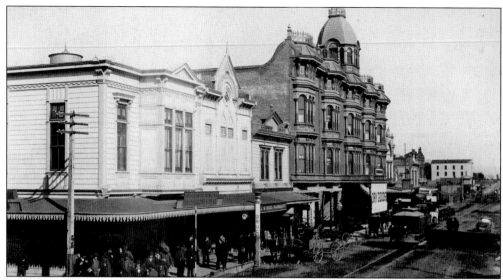

In 1898, a new state law spurred city officials to mandate that excessive signage, sidewalk displays, advertising posts, and possibly even the writing on awnings be removed from commercial corridors. The businesses along Colorado Street had different views on the ordinance, although nearly all balked at removing awning lettering. Taken before the law went into effect, this view looks east on Colorado Street from Fair Oaks Avenue. (Photograph by Jarvis.)

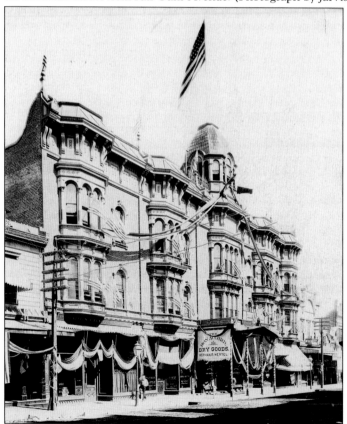

The Carlton Hotel, centrally situated near the intersection of Colorado Street and Fair Oaks Avenue, is draped with patriotic bunting, perhaps in anticipation of President Harrison's visit. The Carlton opened for business in 1886, advertising rooms available on the "European plan" and for "reasonable prices." Businesses such as the Bon Accord dry goods store and the Pasadena National Bank occupied the ground floor.

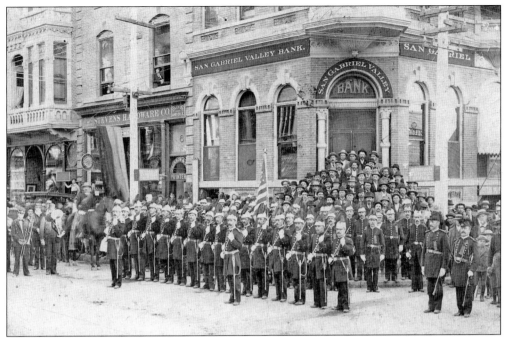

The Knights of Pythias was one of the town's earliest fraternal organizations. The Pasadena lodge started in 1885, some 21 years after the organization was founded in Washington, D.C. Dedicated to the cause of universal peace, the group counted many of Pasadena's early leaders among its local lodge members. This photograph was taken in 1898. (Photograph by J. Hill.)

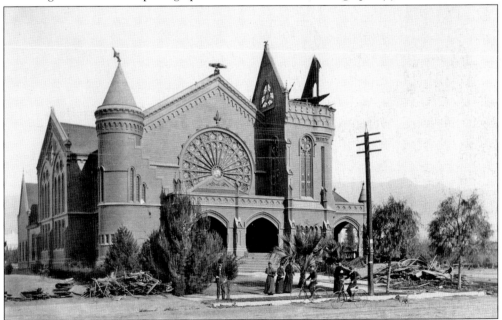

The Presbyterian church on Colorado Street and Worcester Avenue suffered damage from a severe windstorm on the evening of December 11, 1891. The structure was renovated and painted in 1902 at a cost of $1,218, under the supervision of local architects Greene and Greene. (Photograph by Crandall.)

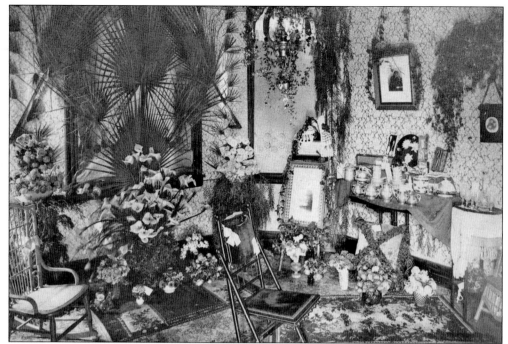

In 1891, Pasadena resident Catherine Cook married Lemuel Langstaff Test in the living room of her parents' home, seen here in its wedding finery. Cook's father, a carpenter, likely oversaw construction of this house himself. (Photograph by Crandall.)

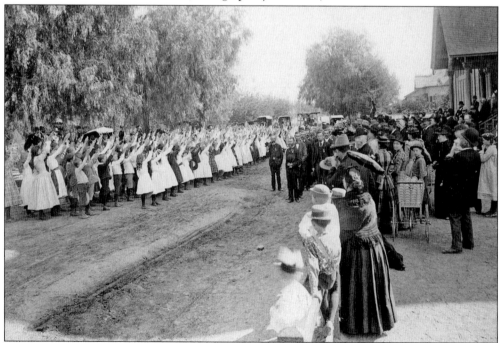

Students at Pasadena's Lincoln School pledge allegiance to the flag during a special Columbus Day program held on October 21, 1892. Years later, in 1918, the building would be destroyed by a rare Pasadena cyclone. (Photograph by Hill.)

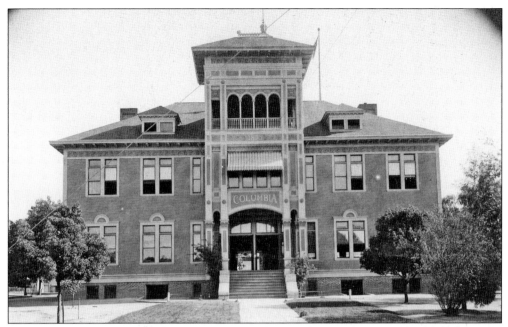

Columbia School stood on Lake Avenue just south of Walnut Street. It was established in 1895 and closed in 1930. Students moved in and out of Pasadena's public schools for a variety of reasons; in 1903, records show that sixth-grade pupils at Columbia were "expelled for bad language," had "measles in family," "moved," and "left for private school."

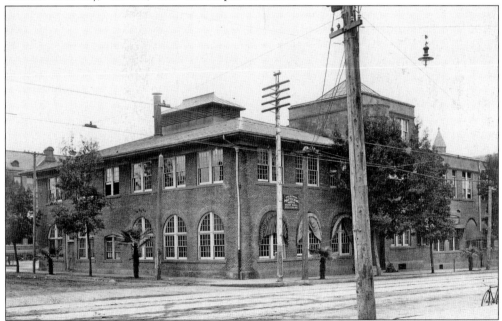

Throop Polytechnic Institute, whose west hall is pictured here, opened in 1891 and by 1892 had acquired land for an enlarged campus on Chestnut Street. Throop's goals were, as described by J. W. Wood, "providing a better education for young men and women, making the men better citizens, and the women better wives." The school would later evolve into California Institute of Technology. (Photograph by F. P. Whitcomb.)

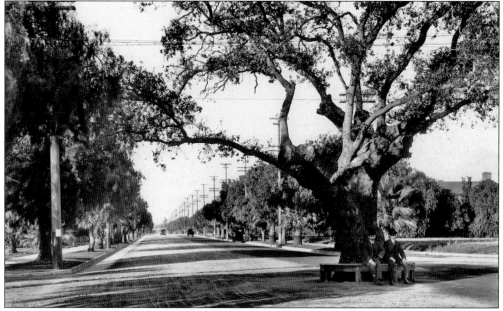

"Pasadena was a place full of charm in the decade before the turn of the century," reminisced old-timer Charles Coleman. "The tourists came to visit one year and the next winter returned to stay." Many of the wealthiest tourists lived on or near Orange Grove Boulevard, informally called Millionaire's Row. The picturesque intersection of California Street and Orange Grove Boulevard features a live oak tree and a bench.

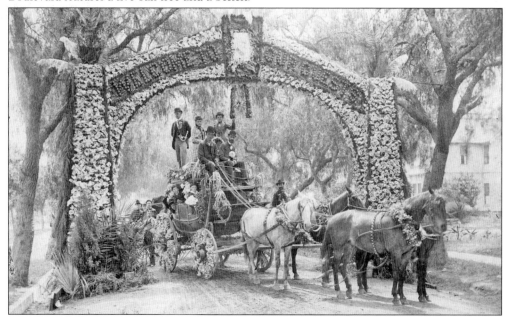

In April 1891, President Harrison paid a visit to Pasadena. Enthusiastic residents pulled out all the stops to ensure that their young city was suitably attired for this important event. One such decoration was this floral arch near the intersection of Marengo Avenue and Kansas (now Green) Street. The arch was decorated with calla lilies and pampas grass, with "Welcome to our guests" spelled out in oranges.

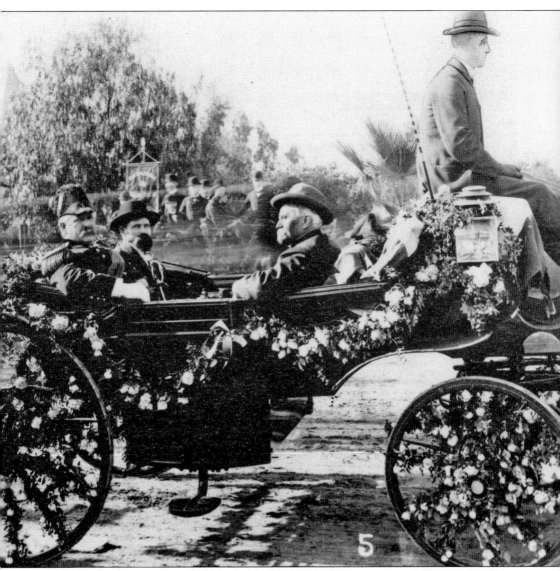

In general, Pasadena was a Republican stronghold during the 19th century. The city was elated by Harrison's election in 1888, with one notable headline proclaiming, "Ben Harrison Elected President by Grace of God and Republican Voters," but by the time of this presidential visit in April 1891, Republicans were less happy with him. When Harrison received the party nomination in 1892, it took encouragement in the form of H. E. Lawrence, a local newspaper editor, parading the streets with a flag to get Republicans to officially ratify his selection. When the president did visit, he was treated to an elegant banquet at the Hotel Green, followed by a public reception that gave several thousand people the chance for a handshake. The next day featured a parade through what turned out to be one of the foggiest days in Pasadena history.

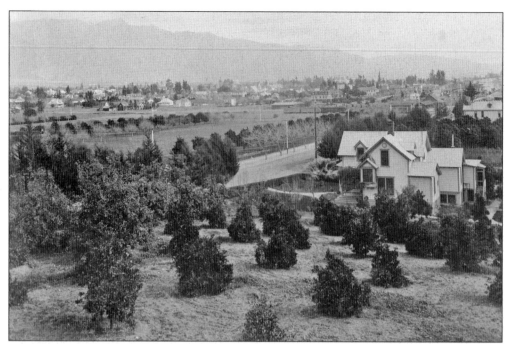

This view of the growing town looks northeast from Terrace Avenue and Howard (now Green) Street in February 1894; Colorado Street is visible in the foreground. Although Pasadena could not yet fully be considered a city, it was certainly expanding in size, and its agricultural lands were already being subdivided for single-family homes. (Photograph by J. Hill.)

Grown in just one season, this tomato plant reached an impressive height of 13 feet. The photograph was sold to tourists as a memento to send to friends and relatives living in colder climates with shorter growing seasons. (Photograph by J. Hill.)

Devil's Gate was an outcropping of boulders located in the Arroyo Seco. Named for the image of the devil's head that some saw in the rock formation, the site was a popular location for picnics. Devil's Gate later became the location of the Devil's Gate Dam, built in 1920. Here sightseers pose on an outing to the area. (Photograph by J. Hill.)

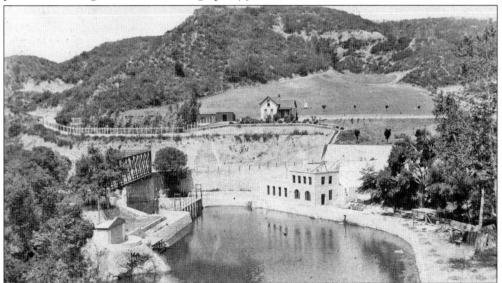

In the late 19th century, James Scoville financed the construction of this bridge and this dam—the first in the Arroyo Seco—to assist with the irrigation of orange groves in adjacent San Rafael. The Scoville Dam was built just north of where the Colorado Bridge now stands. This photograph was taken in the early 1890s.

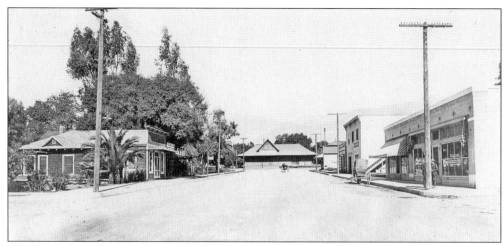

This business district was located near the intersection of Rose Avenue (now San Gabriel Boulevard) and Nina Street in east Pasadena. At the time this photograph was taken, probably in the 1890s, the Lamanda Park area was not officially part of Pasadena. Lamanda Park's business district revolved around the train station—visible at the end of the street—which served to distribute agricultural products across the nation.

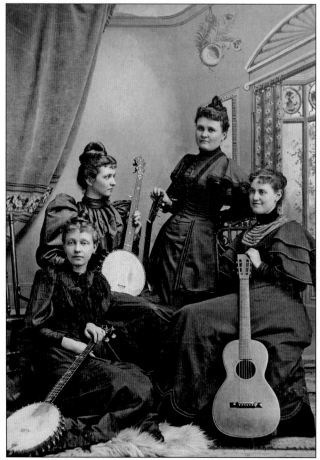

Ella Cockrell Hardison, Grace Weingarth Hodges, Ida Whithouse, and Betty Bushnell gathered to form the Pasadena Musical Group, shown in 1890. Music played an important role in local culture during this era, with concerts by both amateurs and professionals always well attended. (Photograph by Crandall.)

Delos Jones is pictured in 1898 before leaving to fight in the Spanish-American War. (Photograph by Baldwin Photograph Company.)

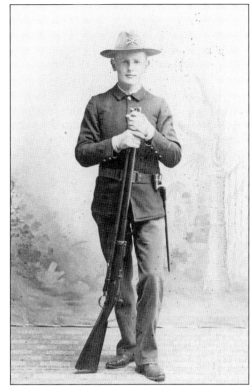

Pasadena's Central Park, shown sometime before 1898, was located between what is now South Fair Oaks Avenue, East Daytona Street, South Raymond Avenue, and East Del Mar Avenue. (Hiller collection.)

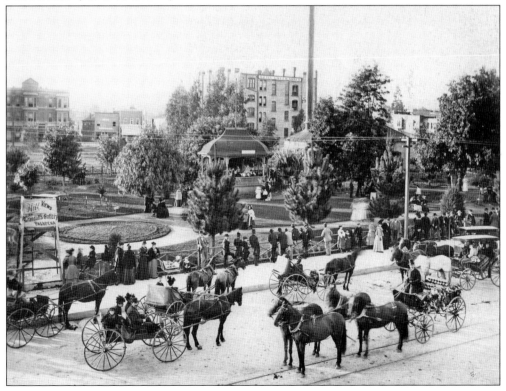

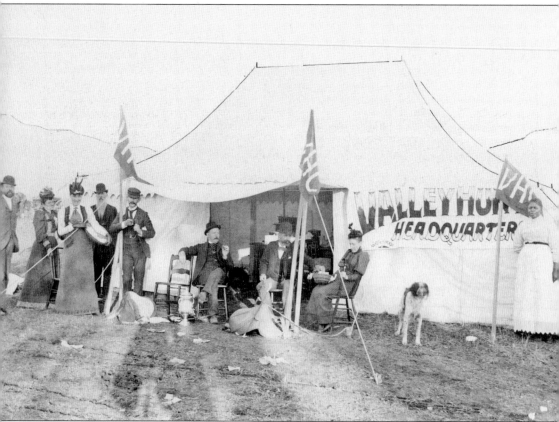

The Tournament of Roses and its New Year's Day celebrations got their start when the Valley Hunt Club decided to host a parade filled with floral-draped wagons and buggies, followed by games such as footraces and tug-of-war. The club's headquarters is seen here during the 1893 tournament. (Photograph by J. Hill.)

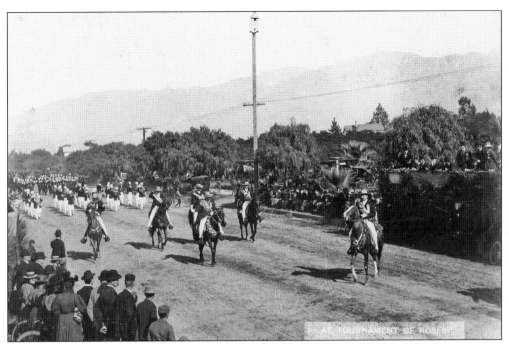

Mounted riders participate in the 1896 Tournament of Roses parade, followed by one of many bands. After the 1895 parade, the official Tournament of Roses organization was formed to take on the duties relating to the growing event. Members immediately began work, raising nearly $600 from the public to assist with costs. (Photograph by J. Hill.)

A tally-ho sits outside the original Hotel Green building, preparing to ferry riders to a local tourist destination such as the San Gabriel Mission, or perhaps Altadena's poppy fields. Tally-hos, a familiar sight around the city, functioned much as tour buses do today. (Photograph by J. Hill.)

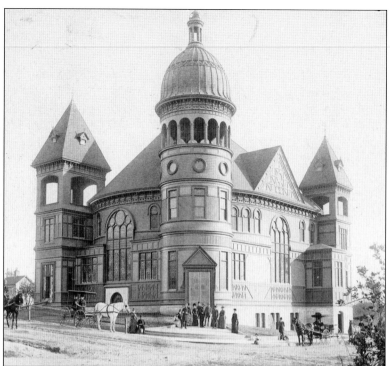

The Universalist church, shown in the 1890s, was located on the northeast corner of Raymond Avenue and Chestnut Street. It was dedicated on April 13, 1890. (Photograph by Lamson.)

This classroom photograph was taken just prior to an 1898 Easter Sunday Bible school lesson at Pasadena's First Congregational Church. The students studied under the guidance of teacher Grace Dutton and Bible school superintendent A. L. Hamilton. The church was located at Pasadena Avenue and California Street.

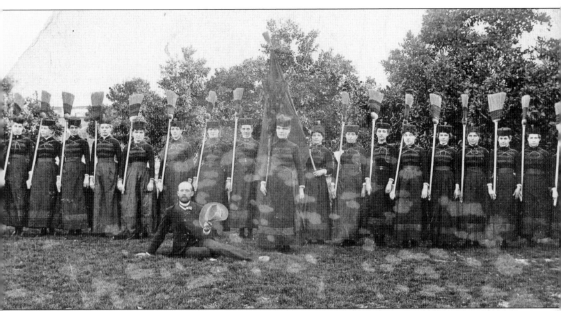

The members of Pasadena's all-female Broom Brigade, pictured in 1886, were trained to do military-style drills—with brooms—by Lieutenant Rockwood, a retired military man from New York. The girls performed at fund-raising events held by the Pastoral Aid Society of the Presbyterian church. The brooms and other accessories were sometimes auctioned off to the enthusiastic audience, thereby raising more money for the organization. Many of these girls were of wealthy backgrounds and would not have to use brooms in their regular lives, adding a greater element of fun and exoticism to the broom-and-dustpan drills.

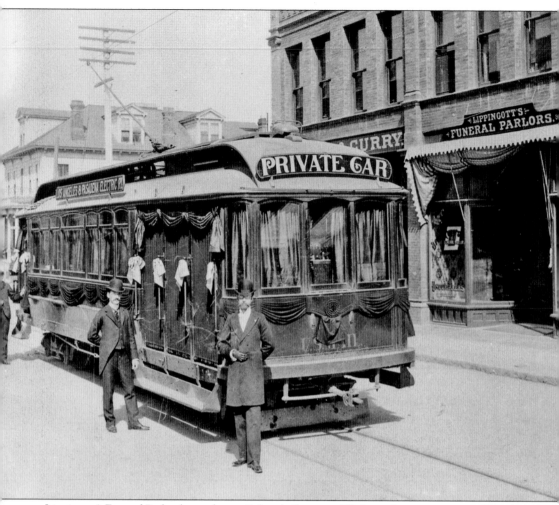

Lippincott's Funeral Parlor, located near Colorado Street and Delacey Avenue, was one of Pasadena's earliest. Following a ceremony or viewing, the casket was loaded into a private streetcar like the one here. The streetcar, appropriately draped with black cloth and other evidence of mourning, then carried the casket and mourners to Mountain View Cemetery.

Three

THE CITY OF CIVIC PRIDE
1900–1910

In the early 1900s, Pasadena began to earn the title of "city." Its population continued to grow, along with the amenities necessary to serve residents and visitors alike. The city had 4 movie theaters, 48 churches, and 12 public schools, including Throop Polytechnic School. Pasadena was well connected, with 5,100 telephones, the equivalent of one telephone for every family.

Despite Pasadena's expansion, it still retained vestiges of its agricultural past as well as large areas of farming land. In 1907, Pasadena shipped or produced, among other things, 30,000 train carloads of citrus fruit, 500 carloads of cabbage, 3,000 carloads of celery, 5 million pounds of butter, 2 million gallons of pickled olives, and 200,000 gallons of olive oil.

Tourism continued to be a major component of the economy. The city's grand hotels attracted hundreds of visitors from around the country, including some of the wealthiest families in America. Among the well-known names of those who chose to build their own seasonal or permanent homes along Orange Grove Avenue were Wrigley, Gamble, and Busch.

Pasadena also blossomed as a design center. The Arts and Crafts movement had swept through parts of Europe and the United States and attracted a following in Pasadena, most significantly manifested through the city's architecture. Architects Greene and Greene designed many homes and buildings in the city, including the Gamble House in 1908.

Pasadena's boundaries also grew during this period; north Pasadena was officially annexed, adding two square miles and 2,500 people to the city.

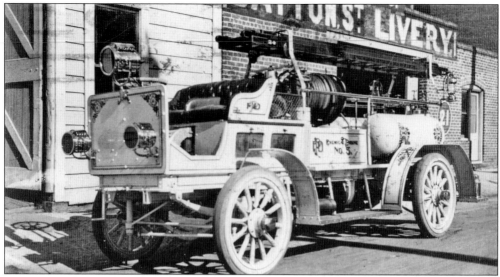

Shown in 1909 is Pasadena's original motorized fire engine, allegedly the first west of the Mississippi. It was the most modern technology available at the time. The 1909 model was manufactured by the Seagrave Company, one of the country's oldest and best-known fire engine manufacturers.

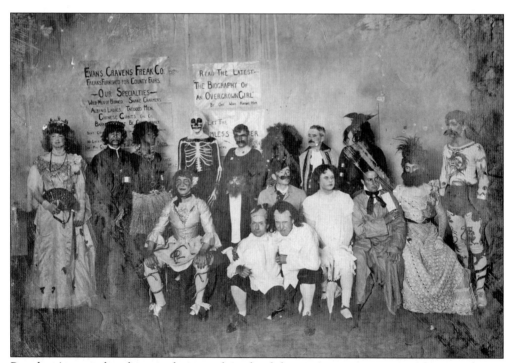

Pasadena's resort hotels were the site of much of the city's entertainment options and were frequented by locals and visitors alike. One such activity was this circus sideshow, held in a crowded tent on the grounds of the Hotel Raymond. Stars of the show included a man-eating gorilla, a "$10,000 beauty," a tattooed man, a "wild man of Borneo," a glass eater, a skeleton man, and a bearded lady.

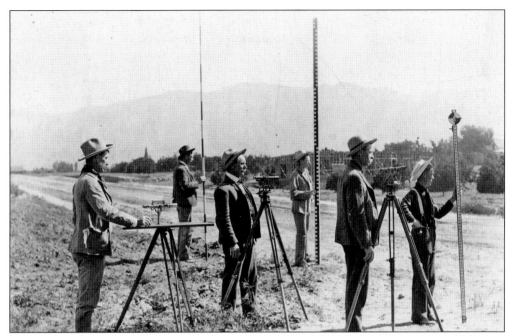

Land surveys such as this must have been regular sights during the 1900s, a period of great residential growth in the city. Many large tracts were subdivided and sold as single home lots. The city struggled to meet the needs of its booming population. This 1906 survey was undertaken by Charles Hartley, Fred Krake, and Jack Rowsh on behalf of the City of Pasadena.

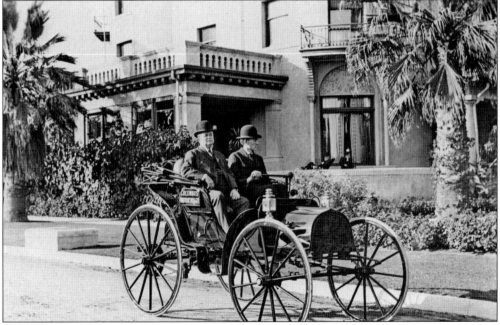

This Columbus motor buggy, allegedly Pasadena's first taxi, sits outside the Hotel Green. While some seasonal tourists depended on drivers or taxis, others brought their cars with them for the winter. This stirred up controversy in 1909 when the county started to tax cars owned and used by winter tourists, although the new law only impacted about 500 automobiles in the county.

Following his move to Pasadena in 1903, Adolphus Busch decided to commission a garden inspired by those in his native Germany. He commissioned landscape architect Robert Fraser to develop gardens on land extending between Bellefontaine Street and Madeline Drive on the north and south and Orange Grove Boulevard and the Arroyo Seco on the east and west. After three years and $2 million, the gardens opened to the public.

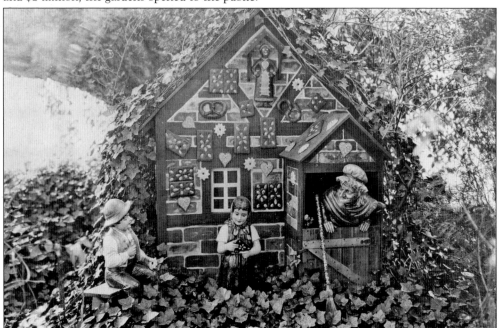

Busch Gardens, with its whimsical plantings and ornamental features, was free to the public during Adolphus Busch's lifetime. Visitors could wander the more than 14 miles of pathways, enjoying scenes like this at the Hansel and Gretel cottage, along with the mystic hut and grotto, the sunken gardens, and a working mill.

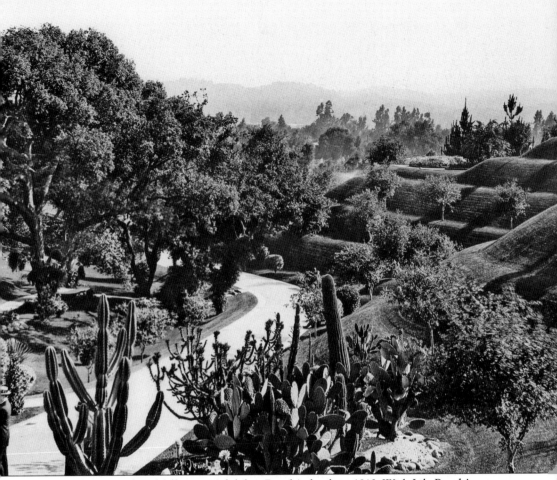

Busch Gardens was closed following Adolphus Busch's death in 1913. With Lily Busch's support, the site reopened in 1919, this time with a small admission fee dedicated to the Pasadena Hospital. The gardens remained popular, and the hospital raised $36,000 in just 16 months. In 1921, the American Legion acquired the attraction, charging a 25¢ admission to benefit war veterans. Lily continued several traditions, including the famous Easter party. Each Easter, she invited hundreds of orphans and needy children to the gardens for a festive lunch and Easter egg hunt, with many of the decorative eggs painted by the hostess herself. Following Lily Busch's death in 1928, Busch Gardens closed yet again. Despite a brief reprieve by the Pasadena Civil Relief Association in 1933, the gardens had come to the end of its life. Some 15 acres were subdivided for homes in 1937, with the remaining land sold for homes in 1945. Today Busch Gardens is a fully developed residential neighborhood, though traces of the old can still be found if one looks hard enough.

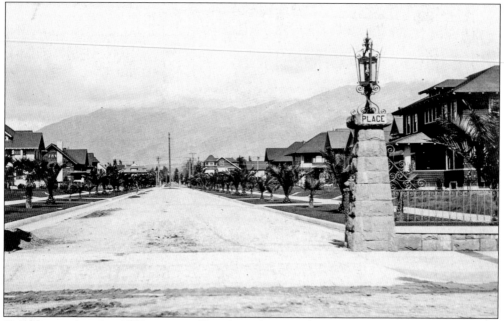

Ford Place, pictured in 1907, was one of Pasadena's booming housing developments. The *Pasadena Star* called Ford Place "the most select residential tract in the northeast portion of the city." Originally owned by Frank Rider of South Pasadena, the property was divided into small residential lots that were sold to the thousands of new residents arriving every year.

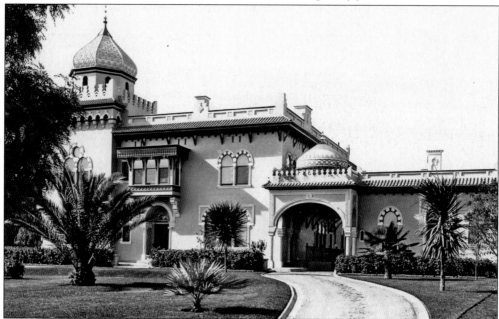

This elaborate Moorish-style residence was home to Dr. Adelbert Fenyes and his wife, Eva, at 251 South Orange Grove Boulevard. They lived in this home for only a short time before moving to another equally grand home, also located on Orange Grove. The family later donated that building to the Pasadena Museum of History for operation as a historic house museum. The house in this photograph does not survive.

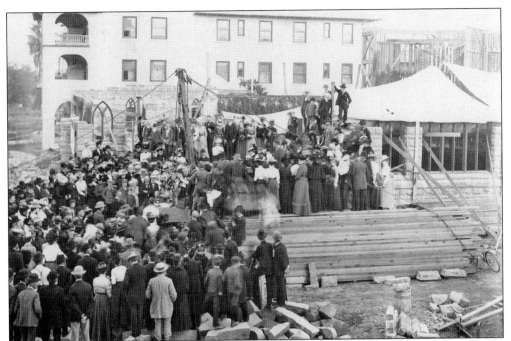

Members of Pasadena's First Methodist Church came together in December 1900 to lay the stone for their third church. More than $30,000 had already been raised toward the $80,000 project. The church was formally dedicated in December 1901, accomplished debt-free after a motivational sermon given by Bishop Earl Cranston brought in $30,000 worth of pledges from the church's approximately 700 parishioners.

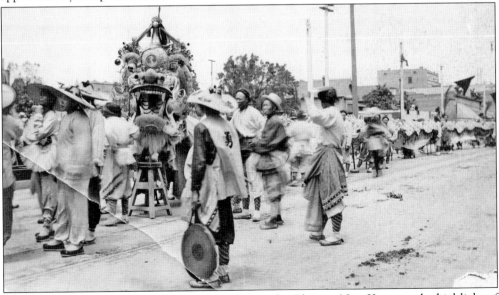

For Pasadena's relatively large Chinese population, the Chinese New Year was the highlight of the season. The week surrounding the holiday was, according to the *Pasadena Daily News*, the only time during the year that "the Chinese laundries are closed, the doors are locked, the stoves are cooled." People celebrated by setting off firecrackers "by the bunch," as well as traveling to Los Angeles's Chinatown for a bigger parade and festival.

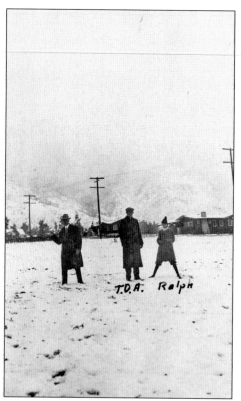

Despite its reputation for a sunny, warm climate, Pasadena does occasionally experience snowfall. Here an unidentified man (left), T. O. Allin (center), and Ralph ? frolic in a short-lived snow on a December day in north Pasadena. Many older residents, as well as wintering tourists from the East and Midwest, were familiar with snow, but it was a new experience for younger residents.

The Pasadena Land and Water Company was established in 1882, following the expiration of the original Orange Grove Association charter. It later became part of the City of Pasadena's water system. The company was still a private endeavor in 1903, the year that this dam and pumping station were photographed.

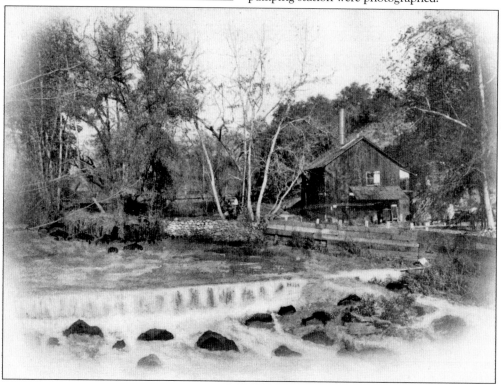

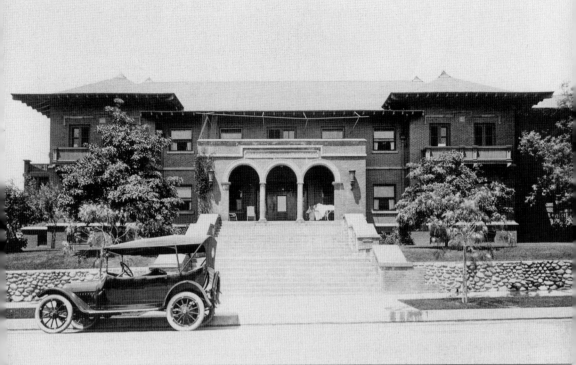

In the late 1800s, O. S. A. Sprague, a prominent Chicago businessman who owned one of the nation's largest wholesale grocery companies, contracted tuberculosis along with his wife and niece. Like so many other wealthy yet ill men and women of the time, Sprague made his way to Pasadena, hoping that the climate would offer a cure or at least a reprieve from the disease. Sprague; his wife, Lucia; their sick niece; and their healthy daughter Lucy lived in a house on South Orange Grove Boulevard and Terrace Drive. After Lucia succumbed to the disease in 1901, Sprague donated this building to the larger Pasadena Hospital in her honor. Named the Sprague Memorial Hospital, it was the first structure built on Fairmont Avenue. Sprague himself died of the disease in 1909.

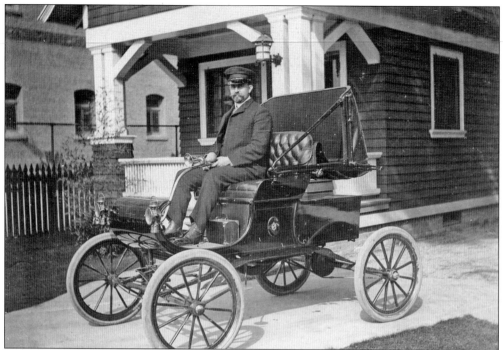

Dr. O. S. Newcomb poses in his car outside his home at 44 South Marengo Avenue. According to a study cited in the *Pasadena Star* in 1908, at the time, Pasadena had more than 1,000 automobiles within its limits. This figure, second only to Los Angeles within Southern California, gave the city the distinction of having the most cars per capita in the world.

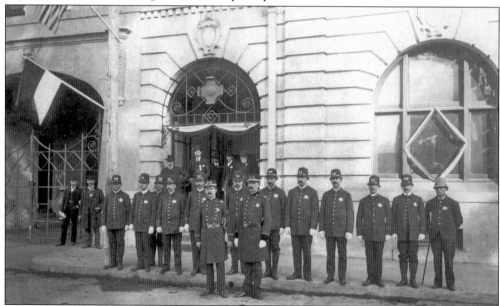

The Pasadena Police Department was founded in 1886 with just one officer. By 1900, the service had expanded, as evidenced by the department portrait taken that year. The city's police handled everything from traffic issues—speeding buggies could be a problem—to more serious crimes such as murder and robbery.

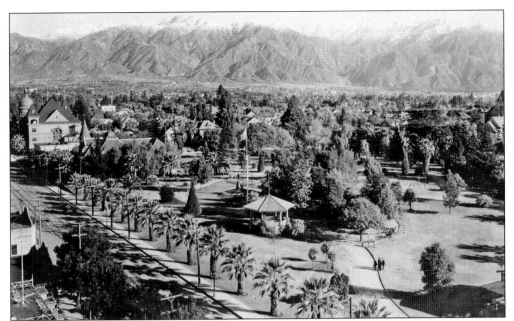

Visible at the upper left corner of Library Park, located on North Raymond Avenue, is the city's 1890 public library. A source of pride for Pasadena, the library was the recipient of much generosity. In 1916, for example, A. C. Vroman donated a large collection of books relating to California and the Southwest, along with a gift of $10,000 to purchase more titles on the topic. (Photograph by Harold A. Parker.)

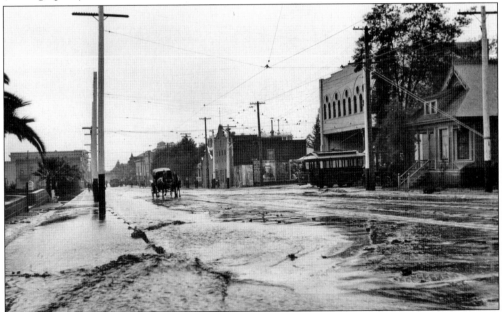

This view, looking south on Raymond Avenue from Walnut Street, records a wet day in June 1906. Although Pasadena was known for its sunny and pleasant climate, heavy rainstorms occurred every year and sometimes caused flooding when the rain came down too fast for storm drains to handle. Streetcars are running despite the water, although few people appear to be out in the streets.

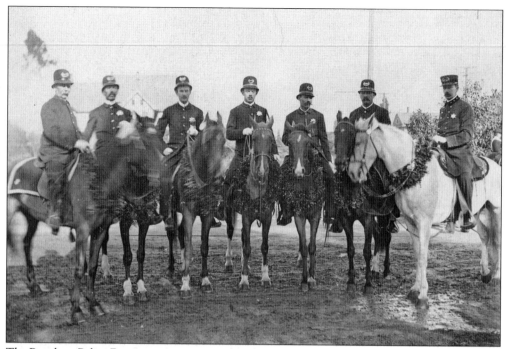

The Pasadena Police Department participated in the 1903 Tournament of Roses parade. In addition, the department had an active role in maintaining order throughout the day. Policemen controlled crowds, discouraged rowdiness, and kept an eye out for pickpockets—an ongoing problem given the large crowds and the day's festive air.

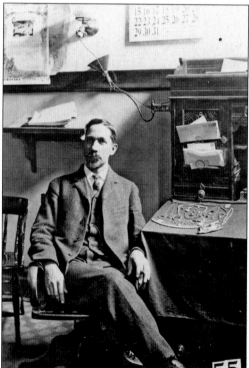

W. W. Freeman, a former member of Pasadena's Merchant Patrol, was appointed chief of police in 1901. During his four years of service, he tackled the range of crime problems facing the young city. One of Freeman's proudest moments was perhaps his role in the return of these jewels, worth $40,000 at the time, stolen from guests at the Hotel Maryland.

A. C. Vroman, the owner of Vroman's Bookstore, the oldest independent bookstore in Southern California, was also a writer, photographer, and collector. Among other things, Vroman collected small ivory Japanese sculptures called *netsuke*. Considered one of the world's best, his collection reportedly ended up at the Metropolitan Museum of Art.

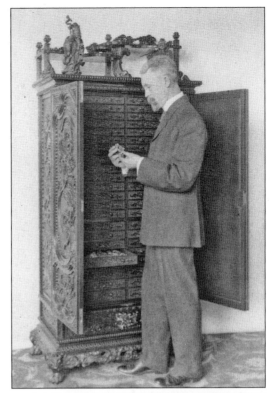

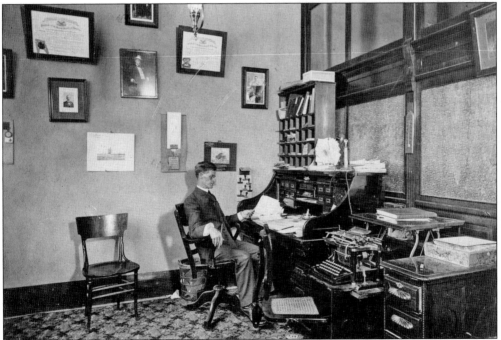

Pharmacist, historian, and politician J. W. Wood poses in his Pasadena office. Wood opened the Pasadena Pharmacy, the city's first drugstore, in 1883. During the first decade of the 20th century, he also served as postmaster; this photograph dates from that time.

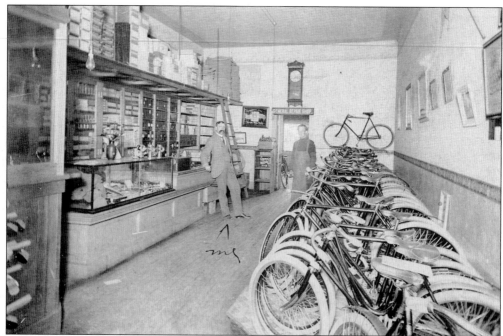

Ed Braley's Bicycle and Sporting Goods Store, located at 31 South Raymond Avenue, was the first bicycle shop to open in Pasadena. In February 1898, readers of the *Pasadena Daily News* learned that "in a few days Ed R. Braley and Co. say they will be able to show the finest chainless bicycle that was ever built." The shop was undoubtedly filled with customers eager to see the latest model.

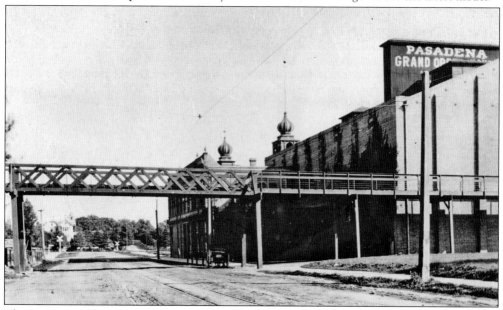

The Horace Dobbins Cycleway, an elevated highway for bicycles, opened on January 1, 1900. The project was to be built in phases, with the first phase running from Pasadena's Hotel Green to South Pasadena's Hotel Raymond and the next phase extending all the way to Los Angeles. Although the Cycleway was never fully completed, for a time, Pasadena's many bicyclists were able to enjoy riding this tollway. (Photograph by R. L. Hirt and Associates.)

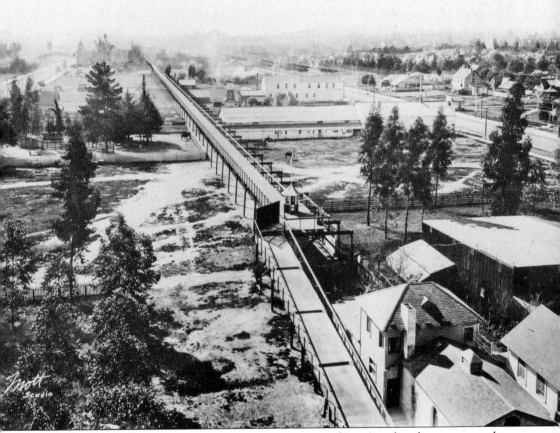

The Dobbins Cycleway extended from the Hotel Green toward Los Angeles; this view was taken from an upper floor of that hotel. "It was quite the thing on moonlight nights to pay the small fee and take a young lady for a spin to the end of the line and back," reminisced Robert Ford in his later years. (Photograph by Mott.)

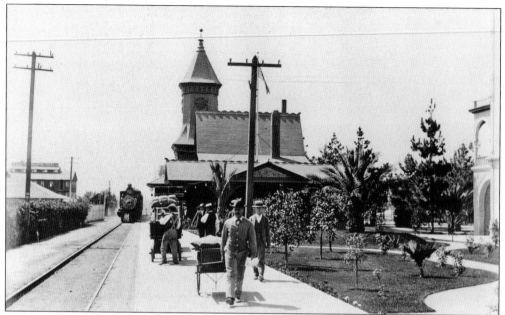

Passengers disembark from an eastbound train at the Pasadena station sometime in the early 20th century. This Santa Fe Railroad depot was built by Edward Webster, the owner of what would become the Hotel Green, with his own money. The $10,000 station was located on Raymond Avenue between Del Mar Avenue and Green Street, conveniently near his new hotel. (Photograph by Warren Brothers.)

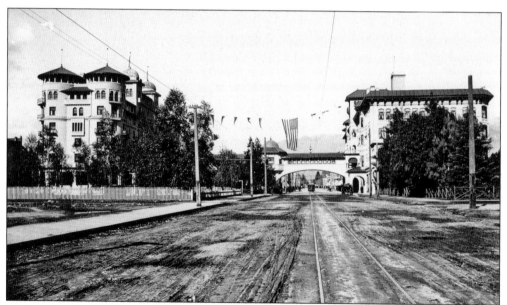

The Hotel Green was one of Pasadena's legendary elegant resort hotels. The business opened in 1890 as the Webster Hotel, but its name changed when purchased by Col. George G. Green the next year. Green expanded the hotel, eventually creating a three-building complex large enough to accommodate the seemingly limitless number of tourists flocking to Pasadena. The bridge spanning Raymond Avenue connected the hotel's east and west wings.

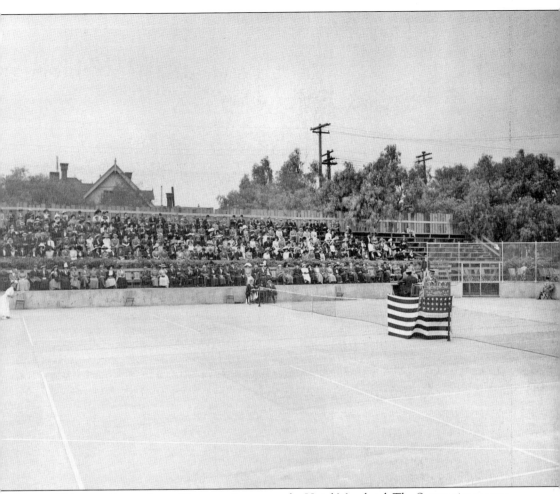

May and Florence Sutton face off in a tennis game at the Hotel Maryland. The Sutton sisters were among California's best tennis players, and in 1905, May became the first American woman to win the Wimbledon singles title. She was also known for her scandalous Wimbledon attire; not only did she roll her sleeves to her elbows, but she also bared her ankles. Back in Pasadena, May's city honored her with the title of 1908 Rose Queen. (Photograph by H. G. Peabody.)

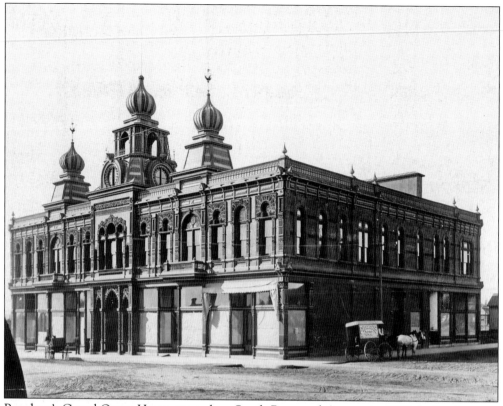

Pasadena's Grand Opera House opened on South Raymond Avenue in 1889, by far the most impressive and ornate building in the city at the time. The opera house experienced a period of popularity in its early years. By the 1900s, however, owner Thaddeus Lowe was experiencing financial troubles, and plans were drawn up to convert the building to a hotel.

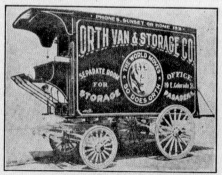

OUR BUSINESS

PACKING
MOVING
SHIPPING
AND
STORAGE
OF
FURNITURE
AND
PIANOS

Orth Van and Storage

301-303 MARY STREET

Both Phones 153

We Ship Household Goods

At a REDUCED RATE to and from Eastern Cities

With so many residents splitting their time between Pasadena and the East Coast, as well as a large number of tourists deciding to make a permanent move to Pasadena, transportation companies such as Orth Van and Storage were kept busy. One of the best-known firms in town, the Orth company packed, shipped, and stored household items for people making long-distance or in-town moves.

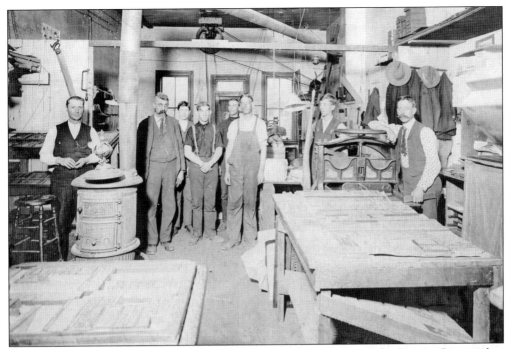

The Jackson Printing Company was headquartered at 40 North Fair Oaks Avenue. Printing has always been a major industry in Pasadena, employing many local men (and sometimes women) and serving the needs of the many businesses and organizations located in the area.

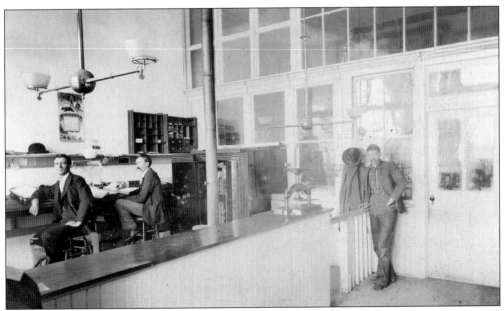

Munger and Griffith, a plumbing store at 21 West Colorado Street, began business as a general hardware store. When founders Austin Munger and Eugene Griffith discovered that Pasadena had a large and as yet unmet need for plumbing and heating supplies, they soon became the city's specialists. This view of the office was taken shortly before 1903, when the partners went their separate ways.

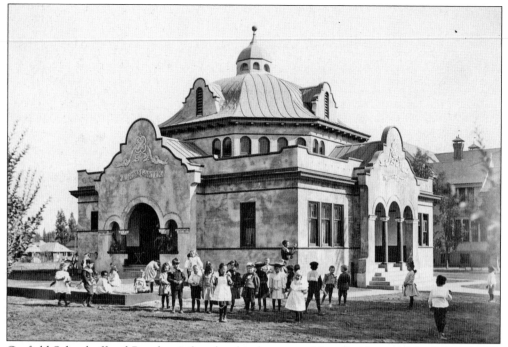

Garfield School offered Pasadena's first free kindergarten. Mary Smith established the school's kindergarten in 1899, funded at her own expense. By 1901, a city charter established five free kindergartens, led by 11 teachers, and made them an official part of the school system. Garfield School's first official kindergarten building, shown here, opened for the 1902–1903 year. (Photograph by Lovick.)

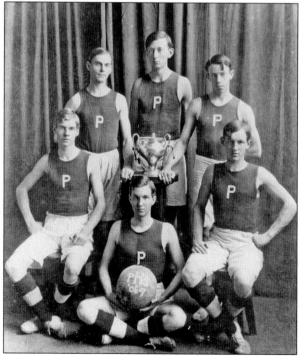

According to the Pasadena High School yearbook, the basketball team of 1906–1907 was "an unprecedented success in every way" and "rolled up scores which our opponents never dreamed of." Although players were beaten once, they "took their defeat as they would have taken victory," a sign of good sportsmanship.

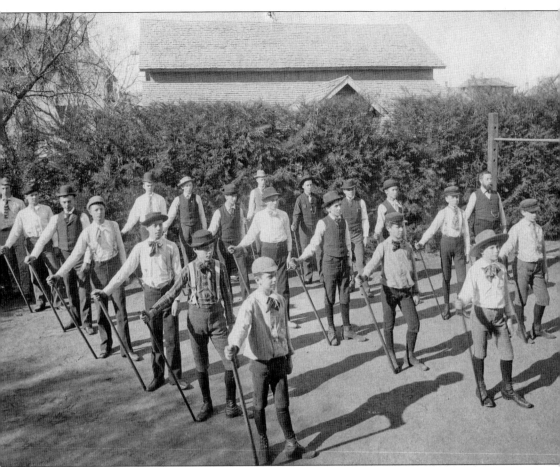

Students from Pasadena's Classical School for Boys participate in the 1902 drill team. This small boarding school was located at 59 South Euclid Avenue and run by historian and Latin scholar Stephen Cutter Clark, along with his brother G. M. Clark. One notable student was George S. Patton Jr., known then as "Georgie." (Photograph by J. Hill.)

Though considered part of the larger elementary schools, Pasadena's earliest kindergartens were held in separate structures. The district initially rented houses and then constructed elaborate buildings adjacent to the schools. Students at Madison School's kindergarten were photographed outside their new building in the early 1900s. (Photograph by Frederick W. Martin.)

In 1901, Columbia School became one of the first in Pasadena to offer a free kindergarten, with a permanent building completed the next year. These kindergartners enjoy their day at Columbia School, located on the southeast corner of the North Lake Avenue and East Walnut Street intersection.

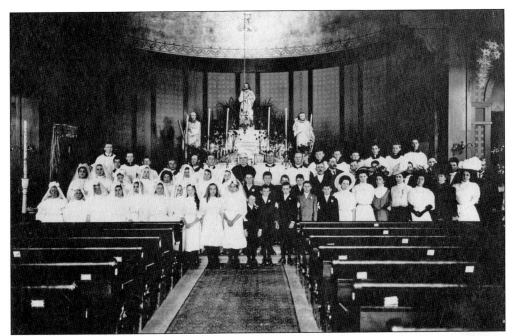

These girls and boys from St. Andrew's Church, the city's first Catholic congregation, participate in their confirmation ceremonies under the spiritual guidance of Fr. Patrick Farrelly in 1908. During Farrelly's tenure, the church opened a school and constructed a permanent church building on Fair Oaks Avenue and Walnut Street.

Pres. Theodore Roosevelt visited Pasadena as part of his 1903 tour of the West. Roosevelt rode through town to Wilson School, located on Marengo Avenue, where he gave a stirring speech. He then called upon President Garfield's widow, who was living on Orange Grove Boulevard, before returning to Raymond Hill and his waiting private train car, filled with Pasadena roses.

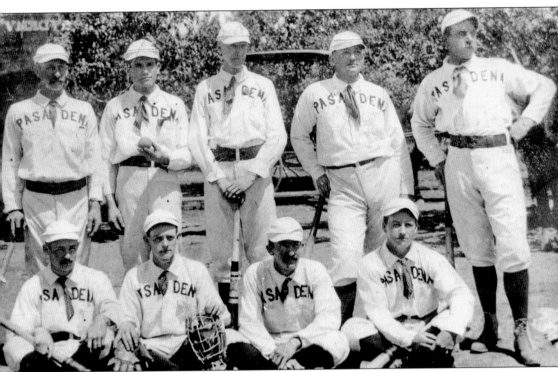

The Merchants, an early Pasadena baseball team, pose in uniforms purchased by local businesses. The city has a long history involving baseball. In 1920, Chicago Cubs manager Fred Mitchell declared Pasadena "the greatest baseball training spot in the world." The Cubs trained here for several seasons, frequently playing games with the Merchants. (Photograph by Downing.)

Four

PASADENA THE BEAUTIFUL
1910–1920

During the years following 1910, Pasadena cemented its status as a city, not just a town. Both population as well as the city's boundaries continued to grow during this time. It was during this decade that the Linda Vista and the San Rafael Heights neighborhoods became part of the city. Located on the west side of the Arroyo Seco, they were connected to the rest of the city by the Colorado Street Bridge, constructed in 1913.

World War I was a major shaping force during this decade. Many of the city's young people, both men and women, served the war effort in some way. The war also had an impact on local tourism; already a popular tourist destination, the city welcomed even more visitors as popular European destinations became inaccessible.

By now, the City of Pasadena was also well integrated into the larger Los Angeles area. A well-developed system of Pacific Electric "Red Cars," the world's largest interurban railway, allowed locals and visitors to easily travel to destinations both near and far. Pasadena retained a strong sense of place, as well as its own downtown, but local residents could also easily access downtown Los Angeles, as well as other regional cities such as Santa Monica and Long Beach.

This decade also brought national attention to the renamed Throop College of Technology (now Caltech); it was during these years that Arthur Noyes, Robert Millikan, and George Hale laid the framework that was to transform Pasadena's engineering school into a world-renowned center of scientific study.

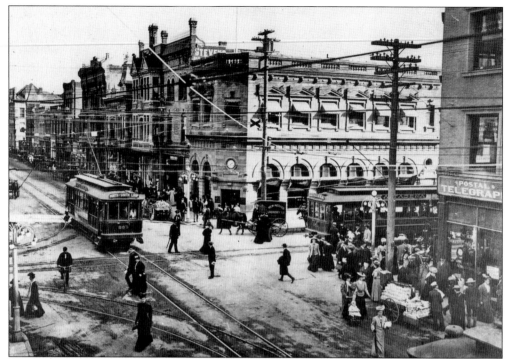

This photograph shows East Colorado Street sometime in the second decade of the 20th century. The street traffic, typical of the time, includes orange vendors, a New Method Laundry delivery cart, and the electric trolley cars from the Altadena and North and South Loop lines. The ready availability of oranges and other fruits never ceased to amaze the Eastern visitors who filled Pasadena's many hotels.

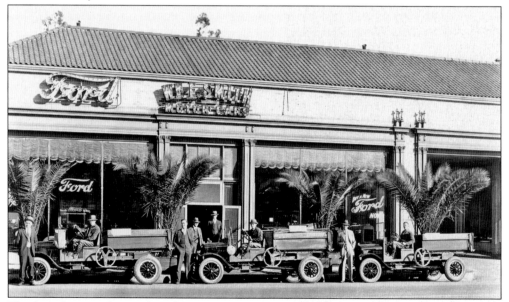

The three dump trucks outside William Smith's Ford Agency, located at 707–709 East Colorado Street, were part of a fleet sold by Ford employee Frank Bahr. By 1924, there were 2,865 automobile dealers in California, along with 117 motorcycle dealers. Ford advertised itself as "the universal car."

As automobiles steadily increased in popularity, government at both the state and local levels looked for a way to better regulate the new machines. In 1901, California authorized local cities and counties to issue their own automobile licenses. Many of these early license plates were made of porcelain. The State of California began issuing plates in 1914, giving them directly to dealers to put on the cars sold.

Mrs. Jiggs, pictured in 1918, was used as a practice dummy by students at the Pasadena Hospital School for Nurses. Each year, the school graduated approximately 15 to 20 nurses. The class of 1918 was the 15th to graduate.

Pasadena High School participated in the 1912 Tournament of Roses parade with an *Alice in Wonderland*–themed float. The entry consisted of a 40-foot flatbed truck decorated entirely in pink. On it were 19 girls dressed in Alice outfits. Surrounding the float were boys dressed as griffins, footmen, white rabbits, the king of hearts, and the king of diamonds. (Photograph by Harold A. Parker.)

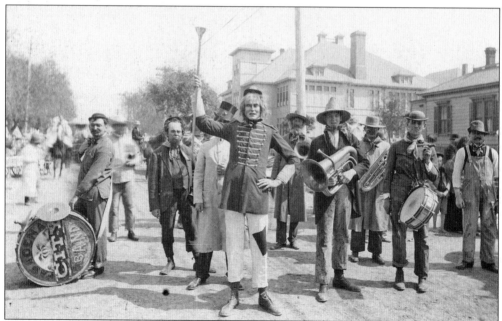

During the second decade of the 20th century, the Pasadena City Band took on the name Komikal Knights of the Karnival on the evening of January 1, when they joined with about 30 other marching bands and floats to provide a "komikal" alternative to the more staid daytime Tournament of Roses. The first parade, held on January 1, 1911, was an instant success.

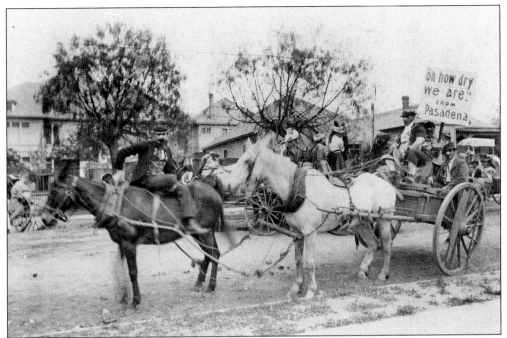

" 'Oh how dry we are' from Pasadena," reads the sign on this float, likely an entry in the evening parade, after the official daytime Tournament of Roses parade. It was designed to poke good-natured fun at the people and events of Pasadena. The city was known for its prohibitionist views, a topic embraced by this float.

Tournament Park, known as "town lot" until 1900, is now a private park owned by Caltech. In 1902, the park hosted a New Year's Day football game. It later hosted the first official Rose Bowl Games between 1916 and 1922, after which the Rose Bowl opened. For many years, the park was also the end point of the Tournament of Roses parade. (Photograph by Frederick W. Martin.)

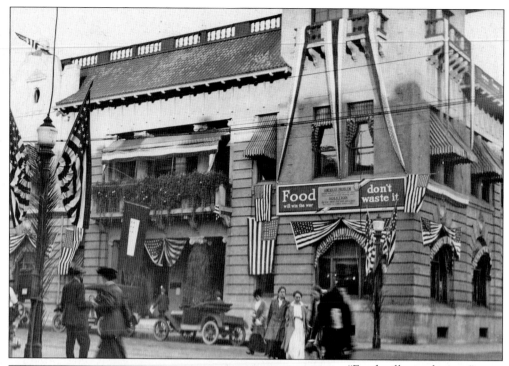

"Food will win the war," states a sign on the Pasadena City Hall, located at Fair Oaks Avenue and Union Street. This building was in service from 1903 until 1927, when it was replaced with the elaborate city hall still in use today.

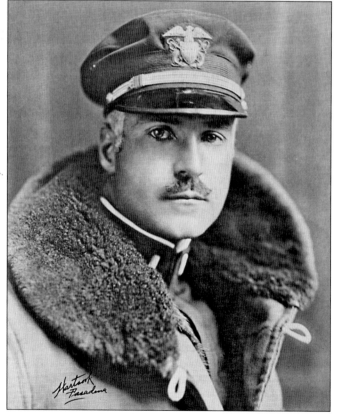

Lt. Ernest Crawford May had this photograph taken in May 1917 when he was 28 years old. It was one of several formal portraits taken at the time, each in a different military outfit. As of late 1917, more than 750 young Pasadena men were either stationed overseas or training in preparation for military duty.

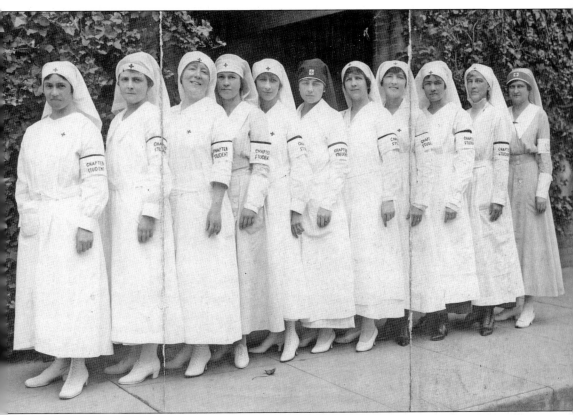

It is a common misperception that all nurses on wartime battlefields were Red Cross nurses. In reality, only those highly trained and qualified were eligible to wear the Red Cross insignia. These nurses had completed two years of training in a general hospital, including experience with male patients. They needed to be endorsed by their training program and by at least two members of the local Red Cross committee. Nurses were between 25 and 40 years old and, during times of war, willing to swear an oath of allegiance to the United States. Once approved, they were issued a badge, a white uniform, and, during wartime, a blue cape. They were paid $50 a month while stationed in this country and received $60 once deployed abroad. On the home front, the Red Cross offered classes in first aid, hygiene, and home care of the sick. These women were Pasadena Red Cross nursing students during World War I.

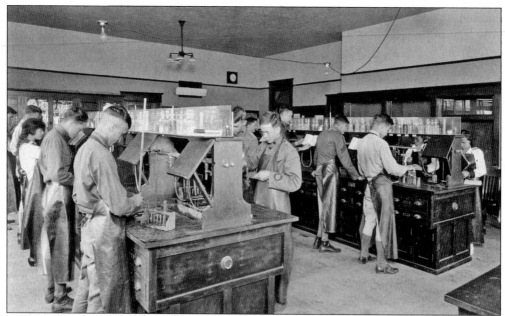

Throop Polytechnic Institute students work in their school's new chemistry building around 1918. Throop, later the California Institute of Technology, was founded by Amos Throop in 1891, with the philosophy that students should use both their hands and their minds. The original school had 10 teachers and 35 students. The chemistry building opened in 1917. (Photograph by Frederick W. Martin.)

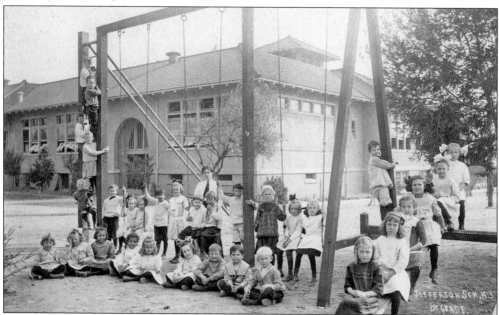

First-grade students from Jefferson School pose on the playground for their official 1913 class portrait. That year, Pasadena ranked highest in the country for school spending per 100 inhabitants—with $899—primarily due to the school system's low teacher-student ratio. "I take these figures to be a distinct compliment to Pasadena," said Supt. J. Rhodes. "It is a good advertisement for the city."

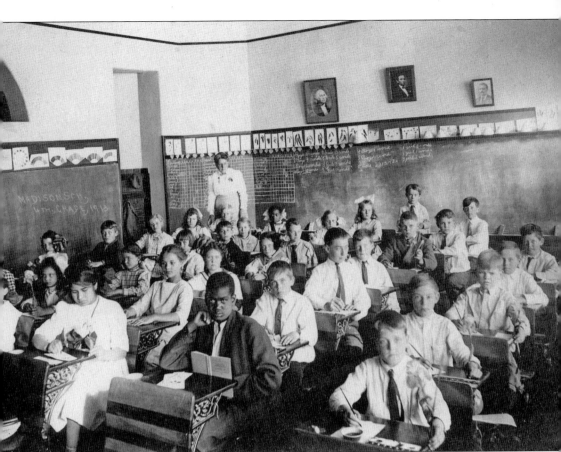

Though the students of Madison School's fourth-grade class of 1913–1914 shared a room and a teacher, there were still many things they would not share outside of school. A close look at the photograph shows a diverse group of students that belies the reality facing minority residents of the city. In Pasadena's early years, racism was less pronounced than in many other areas of the country. That relative tolerance began to change for the worse in the second decade of the 20th century. During the summer of 1914, a controversy broke out after officials announced that nonwhite residents would not be allowed to swim in the city-run Brookside Pool. After much controversy, the city agreed that minority residents could still swim in the pool on one day of the week. Another debate centered on whether streetcar drivers were required to stop for riders of all races; one driver publicly admitted that his "solution" to the question was to just "not see" Mexican, Chinese, and African American riders. (Photograph by H. A. Varble.)

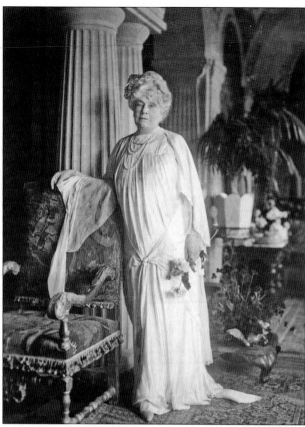

Like many wealthy Americans in the early 20th century, Adolphus and Lily Busch wintered in Pasadena. The couple was well known and connected around the world; when they celebrated their 50th anniversary in 1911, they received gifts from Teddy Roosevelt, President Taft, the emperor of Germany, and many other American and foreign notables. Here Lily Busch poses for a formal portrait.

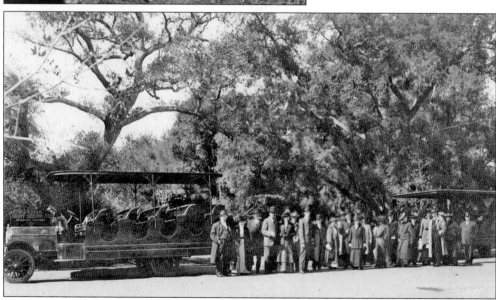

Busch Gardens was a much-beloved attraction in Pasadena. Although the fairytale-inspired gardens closed in 1913 following creator Adolphus Busch's death, they reopened to the public later in the decade. Here tourists take a tram ride through the extensive grounds. Sometimes referred to as the "eighth wonder of the world," the site featured trees and flowers from across the globe.

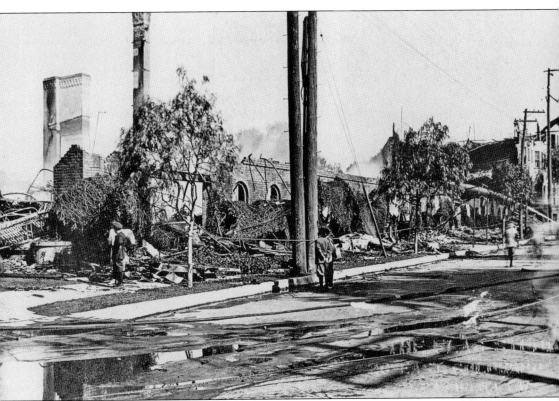

D. M. Linnard, the manager of the Hotel Maryland, addressed the press on April 20, 1914. The grand hotel had suffered great damage during the fire of April 18 (pictured), but Linnard announced that plans to rebuild it were already underway. In the meantime, guests would stay at the nearby Huntington Hotel and in May would be housed in the Maryland's guest bungalows. Linnard thanked the Pasadena Fire Department, the police department, and his own staff for their heroic efforts during the night of the fire. Staff had gone above and beyond the call of duty that night, Linnard said. "I literally had to drive them from the burning building before they were willing to relinquish their efforts to save this beloved hotel from destruction." The blaze had started in a basement storage room, possibly because of faulty wiring or a dropped match, and then made its way into an elevator shaft. The shaft acted as a chimney, spreading fire and smoke throughout the building.

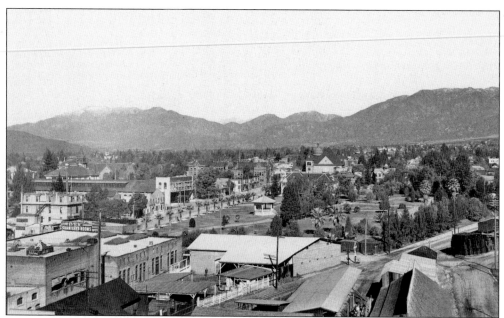

This photograph shows Pasadena's Library Park and its surroundings. The Santa Fe Railroad tracks are visible on the right, while the church with the tower visible at the far end of the park is the Throop Memorial Church, then located on Walnut Street and Raymond Avenue. Library Park was renamed Memorial Park after construction of the new central library on Walnut Street in 1927.

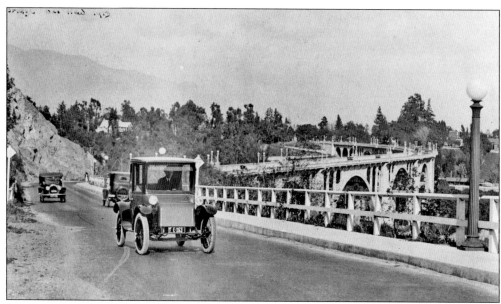

Pasadena's beautiful Colorado Street Bridge opened in 1913, following ceremonies attended by nearly 4,000 people. It was the highest concrete span in the world and the first curvilinear bridge ever built. Here people drive across the bridge shortly after its opening. (Photograph by Harold A. Parker.)

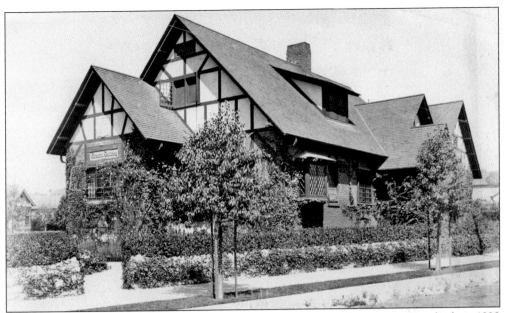

The Stickney Memorial Building, located on Lincoln and Fair Oaks Avenues, was built in 1899 as a memorial to Susan Stickney's longtime friend M. D. Bowler. In 1914, Stickney donated it to the Pasadena Music and Arts Association for an arts school. The Stickney School of Fine Arts would offer courses in charcoal, landscape, pen-and-ink drawing, and still-life painting. The school would draw students from across the state (and possibly country) and would be managed by C. P. Townsley, formerly of the Chase School in New York City, and local artist Jean Mannheim. Prior to use as the school, the building served as a meeting place for the Shakespeare Club and as an art building for the Throop School. (Photograph by C. C. Pierce.)

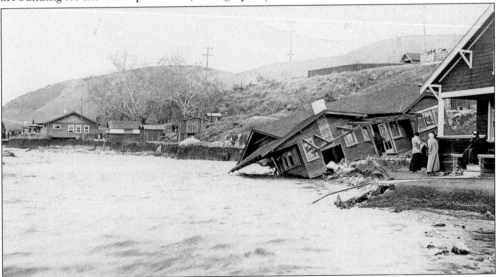

This 1914 flood scene was photographed on Arroyo Drive in northwest Pasadena after a major spring storm. That year was a wet one for California, which experienced several record rainfalls. Northeast Pasadena was relatively undamaged from the excessive rainfall, thanks to a newly installed storm drain. Northwest Pasadena was not so lucky, and many homes, orchards, and streets were damaged by high waters and copious amounts of mud.

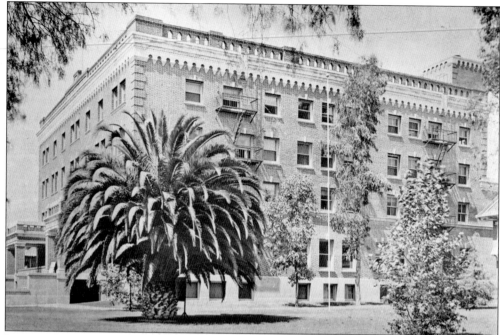

In 1911, the Pasadena YMCA opened this building on Marengo Avenue, where it remained in operation until 1926. In 1914, the *Pasadena Star* reported on the building's new services. Members could now patronize a barbershop, soda fountain, and clothes press shop. The idea was that men could have their pants pressed while swimming. "By this method," said the paper, "one pair of summer 'pants' is enough for any self-respecting man."

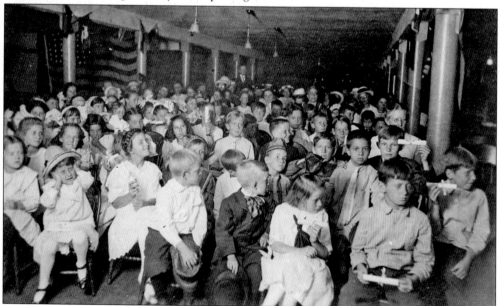

The First Congregational Church, situated at Marengo Avenue and Green Street, held a vacation Bible school for its children. Here students hold diplomas on commencement day in 1914. At that time, the church's slogan was "Come to the Church on Marengo." These children may well have sung a song by that same name, complete with lyrics describing the church and its community.

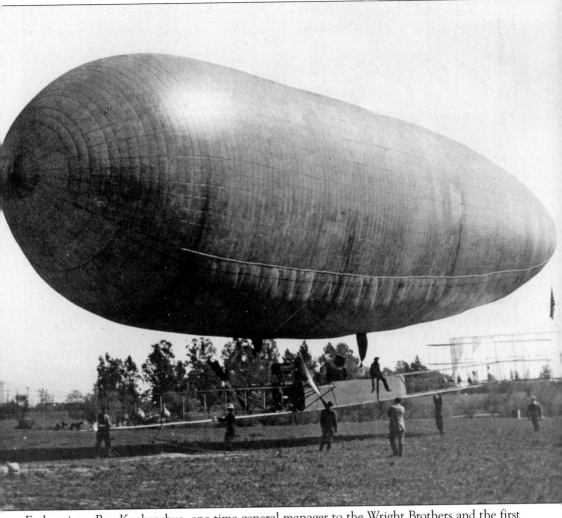

Early aviator Roy Knabenshue, one-time general manager to the Wright Brothers and the first man to pilot a dirigible in the United States, came to Pasadena in 1912 with plans to start the world's first dirigible passenger flight company. Several years earlier, Knabenshue had attempted to convince the city to provide him with a house in return for locating in Pasadena; the *Daily News* reported, "It is figured that with Knabenshue here attention will be directed to Pasadena as a place for aeronautic sports in both winter and summer time." He set up shop near Glenarm Street and Marengo Avenue, conveniently located by the Hotel Raymond and the city's gas works. Wealthy tourists and locals alike paid $25 to take trips on the *Pasadena* to Los Angeles, Santa Monica, and Long Beach. The widespread popularity of dirigibles, or airships, never fully got off the ground, although today blimps are a common sight over the city during events such as the Tournament of Roses and other major Rose Bowl Games.

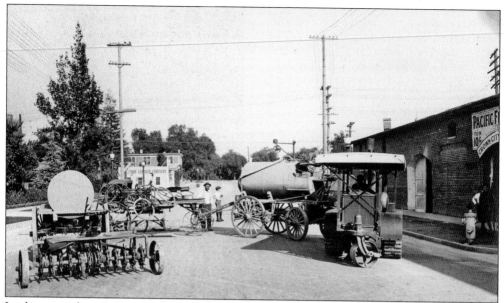

Looking east from Raymond Avenue, this view shows the progress of construction along Holly Street. The Santa Fe tracks are visible. In 1914, business owners along Holly began petitioning for an extension of the street between Fair Oaks Avenue and Marengo Street and another between Fair Oaks Avenue and DeLacey Street. By 1917, construction had started, necessitating the removal of homes and businesses.

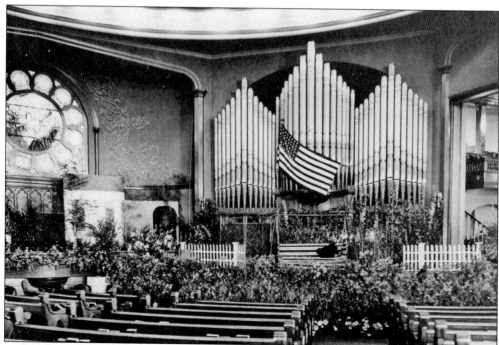

This interior view of the First Methodist Church was taken in 1919, possibly during one of the many pageants held there. Note the large American flag—a familiar sight in Pasadena during and following World War I. City officials asked residents to fly the flag out of patriotic duty. (Photograph by Ralph Wyatt.)

The National Bank of Pasadena was created when three local banks merged in 1912. The newly formed institution flourished, moving into a building of its own in 1913. The bank cost $150,000 to build; its dramatic interior can be seen in this postcard. (Photograph by De Wit and Company.)

Construction of the Pasadena Post Office was well underway on Colorado Street and Garfield Avenue in November 1914. Congressman James McLachlan had secured federal funding of $50,000 for a lot and $200,000 for a building. The lot itself cost $93,000, but local property owners raised the difference. The building opened for use on September 20, 1915.

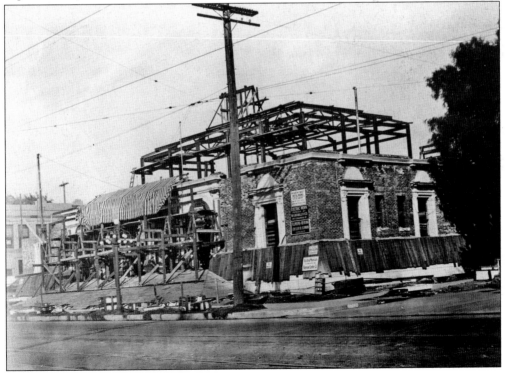

Churchgoers exit Pasadena's First Church of Christ, Scientist, on the southeast corner of Oakland Avenue and Green Street. Everyone is wearing a face mask, an attempt to protect against the deadly flu epidemic that swept across the country in 1918. The masks were not optional; the city required them in the name of public health and safety.

Five

PROSPEROUS PASADENA
1920–1930

The 1920s was a busy decade for the city. A boom in civic building shifted the focus downtown east along Colorado Street, with new civic institutions such as the city hall and public library opening in a new City Center district. The civic center was carefully designed, with city hall forming the axis of a group of buildings. On Walnut Street, north of city hall, stood the new public library, while south of city hall, the civic auditorium would be completed on Green Street. Also included in the plan were other significant structures such as the YMCA, YWCA, Southern California Gas Company, and police department.

Meanwhile, officials were attempting to reenergize the business district centering on Colorado Street and Fair Oaks Avenue. The city completed a 10-year project to widen Colorado Street between Orange Grove Avenue and what is now Arroyo Parkway in 1930, the better to accommodate increased traffic. New building facades were installed during this time in an attempt to modernize the street.

Tourism remained an important element of local life but faded slightly from the dominant role it held in decades past.

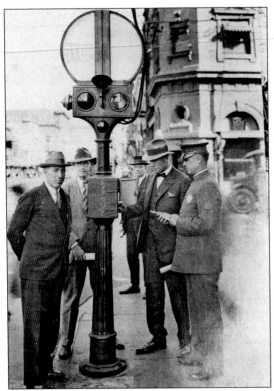

Before traffic lights came into use, policemen were stationed at heavily traveled intersections. The Pasadena Police Department experimented with forms of traffic lights as early as 1921, when the city unveiled a locally invented hand-cranked signal consisting of "Stop" and "Go" signs. The signal in this photograph, reportedly Pasadena's first traffic light, dates to later in the 1920s.

The Pasadena Board of Directors, including chairman Clayton Taylor, welcomed the Goodrich Silver Fleet to Pasadena in May 1929. The distinctive fleet of 14 silver cars and 1 silver truck was on a cross-country public relations tour to promote Goodrich tires.

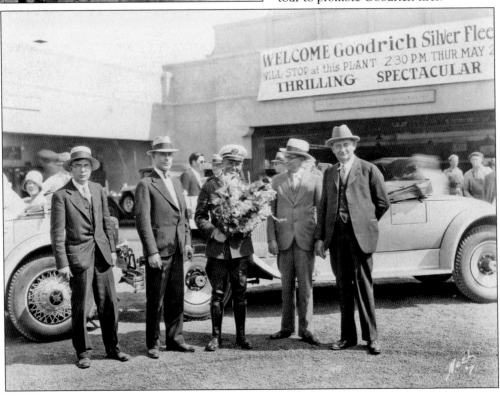

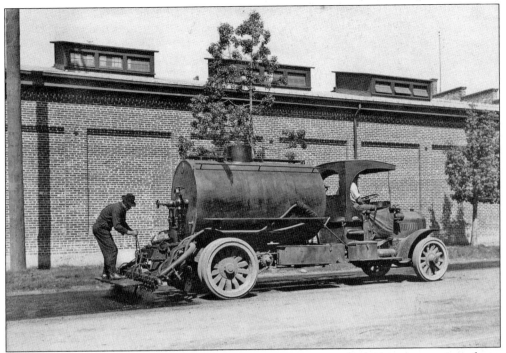

Pasadena continued to grow throughout the 1920s, necessitating both the construction of new roads and the maintenance of existing roads. The widespread use of automobiles was another factor in the increasing and ongoing work necessary to keep the city's streets safe. Here a truck spreads oil during road construction.

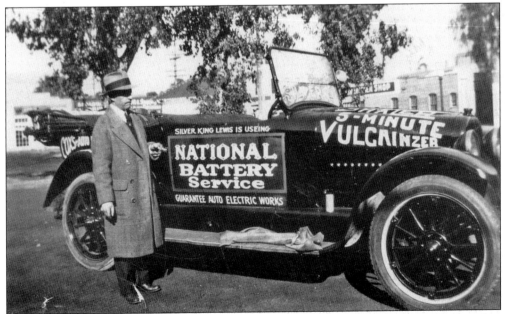

Archie Sparks, an operator at Guarantee Auto Electric Works, poses with a car covered in advertisements in 1924. Located at 97–103 West Colorado Street, the company provided Pasadena's exploding automotive market with batteries and other products.

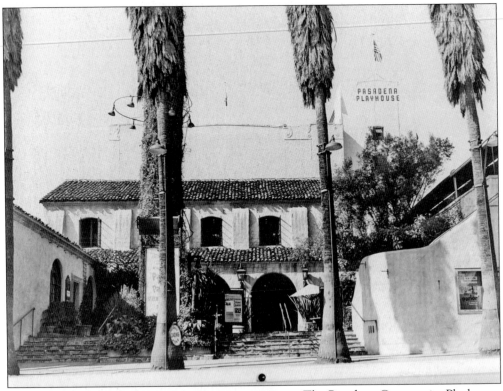

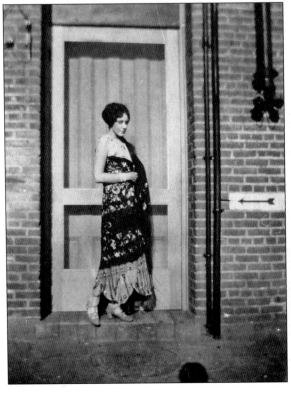

The Pasadena Community Playhouse was founded in 1917, making it one of the nation's earliest community theaters. Their permanent building on South El Molino Avenue opened for performances in 1925. According to the theater's 1920 literature, "As a civic enterprise the Pasadena Community Playhouse is not in competition with any other amusement activity any more than the public library is with the bookstores." The Playhouse also offered a nationally known theatrical school.

Productions were almost entirely volunteer-run, from actors to stage crew. By 1921, the Playhouse was reporting that it had "afforded upwards of 5,000 of our own citizens a chance to play together." This unidentified woman, standing by the stage door of the Playhouse's original Savoy Theater location, was likely one of the 300 or so local actors in the Playhouse's card index of possibilities.

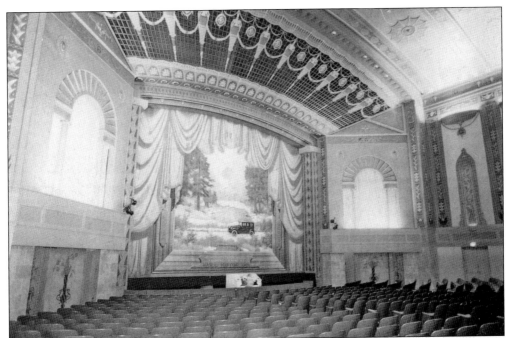

In 1921, the Raymond Theater opened on North Raymond Avenue with great fanfare. The 2,000-seat theater offered up to three performances a day of top vaudeville acts. It was described by the *Pasadena Star News* as the "last word in modern thespian temples." Hull Motor Company was involved as a sponsor, hence the car and the sign visible at the base of the stage.

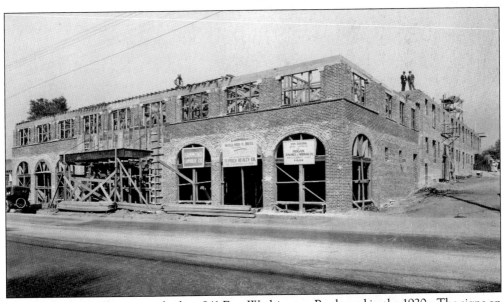

The Washington Theatre was built at 841 East Washington Boulevard in the 1920s. The signs on the sides of the theater are proof of the interconnectedness of the economy—the building was an effort by contractor Willard Bell, Hammond Lumber, and Hogan Finance and Mortgage, as well as all who helped with the actual construction. (Photograph by Harold A. Parker.)

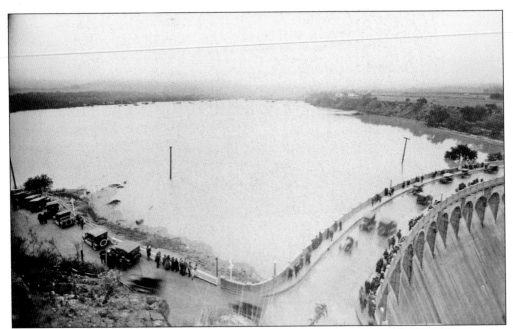

After a series of bad storms during the second decade of the 20th century, it became obvious that flood control was needed in the Arroyo Seco. The storms and resulting floods were destroying orange groves and other property as the water surged downhill. In response, the Devil's Gate Dam opened in the narrowest part of the Arroyo in 1920. Here residents and tourists watch the dam at work in 1921.

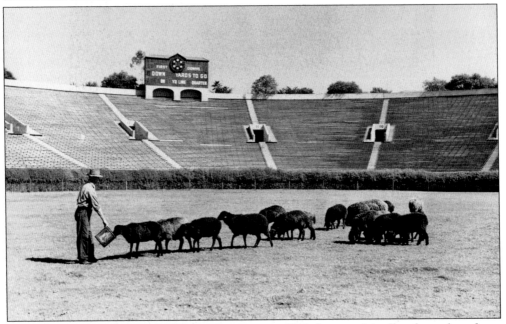

The Rose Bowl Stadium opened for its first game in 1922. It was originally a horseshoe shape with the south side left open. The south side was enclosed in 1929, increasing seating capacity from 57,000 to 76,000. The arena has always been most famous for its January 1 Rose Bowl Game. Here sheep keep the stadium's natural grass trimmed.

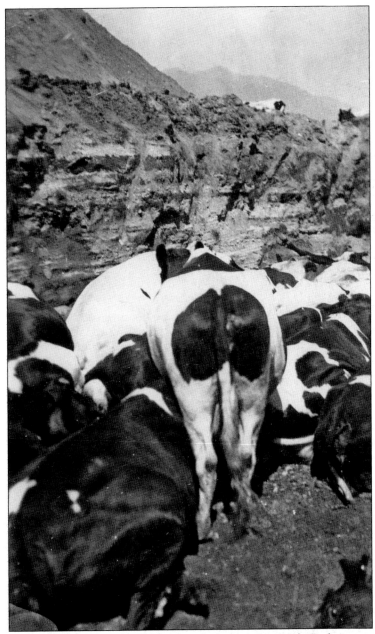

These cattle were killed in east Pasadena, then known as Lamanda Park, in response to the serious epidemic of hoof-and-mouth disease sweeping the state in 1924. Strict quarantine laws went into effect as soon as the disease first struck locally, at the Cold Springs Certified Dairy on San Pasqual Street in Lamanda Park. Guards patrolled the sites of known breakouts; residents were threatened with arrest if they went camping or allowed their pets to run loose. At Cattle Springs, 280 cows were killed and quickly buried in pits filled with lime. The threat was a serious one, and thousands of cattle, hogs, and other animals were ultimately killed in Los Angeles County. Residents, even those who did not own any animals, were kept abreast of the risks and the quarantine laws through newspapers and the more than 50,000 printed warnings distributed by Pasadena Boy Scouts.

Caltech's historic Throop Hall, a concrete building with a tile roof, was once known as Pasadena Hall. The 62-room building was the first to be constructed on the new 22-acre campus. This photograph was taken in 1920, ten years after its completion. (Photograph by Frederick W. Martin.)

Students, faculty, and staff gather to watch Caltech freshmen and sophomores participate in the 1922 pole rush. Life at Caltech could be difficult, so traditions like this helped relieve some of the stress. "I worked hard as a freshman," recalled physics professor and Nobel laureate Carl Anderson of his freshman year in 1923. "I think I worked harder than any year before or after in my life."

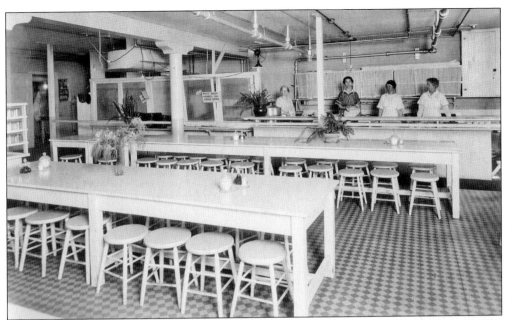

John Muir Junior High was located on Walnut Street between Euclid and Los Robles Avenues. The cafeteria is shown here sometime in the early 1920s. Until 1925, Pasadena school cafeterias were independently operated. That year, the board of education assumed legal authority for the operation of the cafeterias and leased the system's facilities to the Pasadena Cafeteria Association.

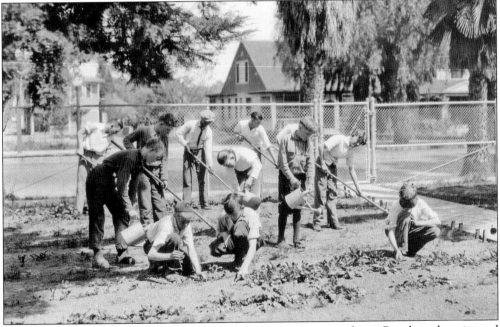

The students at Franklin Elementary School enjoy some time outdoors. Pasadena druggist and active citizen J. W. Wood was one of many local residents who advocated the benefits of outdoor time for students. Wood believed that the "garden and the field offer opportunities for physical training and instruction not found elsewhere" and would help build the city into an educational powerhouse. (Photograph by Frederick W. Martin.)

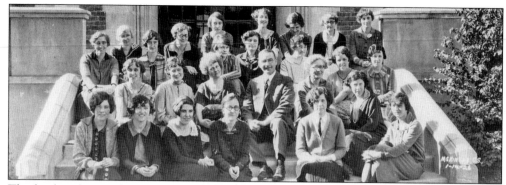

The faculty of McKinley Junior High School poses for an official photograph in 1926. Although an elementary school with the McKinley name had been in Pasadena since 1904, the junior high did not open until 1926. Situated on Oak Knoll Avenue and Del Mar Street, it was the third junior high in the district. In late 1926, the school's PTA gained acclaim with the largest membership in California.

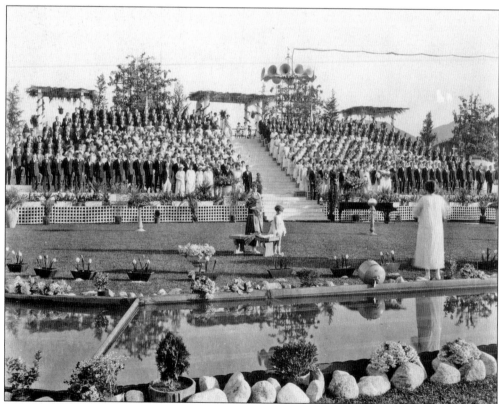

Pasadena High School's graduating class of 1924 held its commencement ceremonies in the Rose Bowl Stadium, transformed for the day into a Dutch landscape, complete with canal and windmill. Junior girls dressed in Dutch-inspired outfits and handed out flowers to the graduates as they walked across the field to receive their diplomas. According to witnesses, it was a "charming scene" not soon to be forgotten.

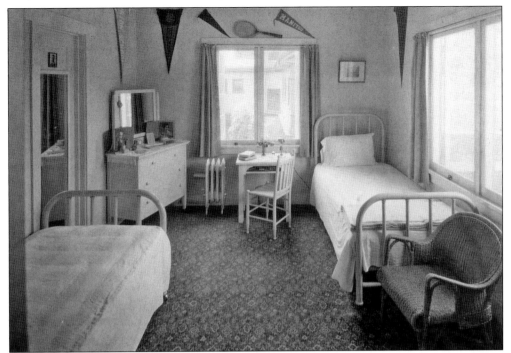

Sisters Anna and Susan Orton founded the Orton Classical School for Girls, a four-year college preparatory high school, in 1890. The campus, including this dormitory building, was located on South Euclid Avenue. One of the nation's best, the institution enjoyed affiliations with schools in Berlin and Paris. Graduates routinely went on to the "Eastern Colleges." Orton closed in 1932. (Orton Collection.)

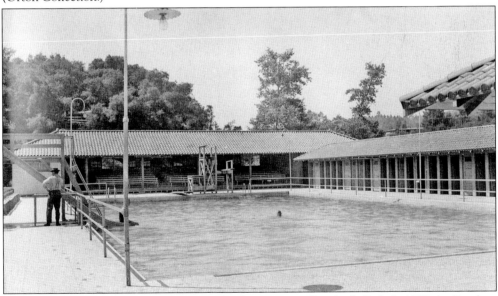

The Brookside Pool, or "Plunge," was a popular destination in Brookside Park. In 1925, the *Pasadena Star News* called the pool, built in 1914 and expanded and improved over the following decade, the "Mecca of swimmers." It was also the source of ongoing strife between Pasadena's nonwhite residents and the city, thanks to regulations limiting access to "International" days.

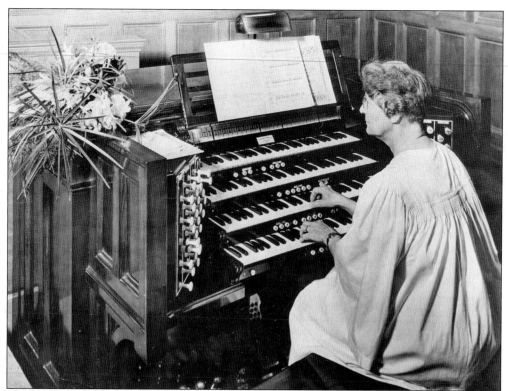

Ada Marsh Chick plays the organ during the dedication ceremonies for Pasadena's new First Congregational Church building on September 22, 1927. (Photograph by R. M. Starrett.)

The planners involved with Pasadena's City Beautiful movement considered Colorado Bridge the primary entrance to Pasadena on the west. In this photograph, cars head east onto the bridge. The span connected the Linda Vista neighborhood of Pasadena to the rest of the city. Even then, Linda Vista had a strong sense of community; the Linda Vista Neighborhood Association was formed in 1924, making it the oldest neighborhood association in the city.

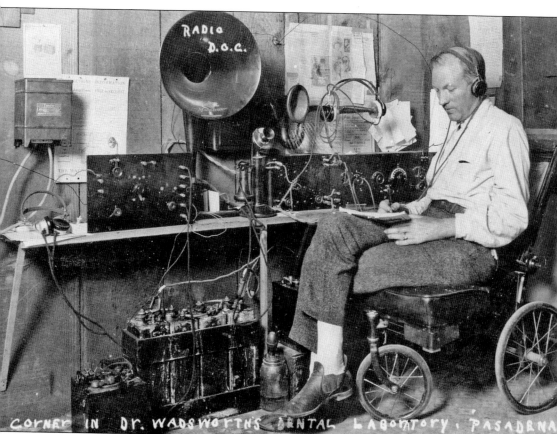

Dr. D. I. Wadsworth, a Pasadena dentist living at 231 North Mentor Avenue, was known as a radio buff. Wadsworth liked to call himself (and his office) Radio DOC. On the back of this photograph, he wrote a note to the Altadena-based radio station KGO: "There is no one that appreciates these radio programs like the . . . invalids like myself, and the good you are doing in the way of furnishing this service, which helps to keep their minds off their troubles, is inestimable." For reasons unknown, the note was never mailed. In the photograph, Dr. Wadsworth sits in a corner of his office, surrounded by radios and radio parts. He would later turn his hobby into a business, advertising the services of the "Radio Doc" in the newspaper and city directories of the time.

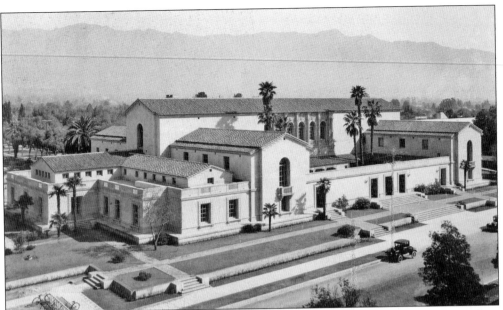

Construction on the Pasadena Public Library began in 1925, following the passage of a $3.5-million bond and a yearlong contest to find the right architect. Myron Hunt and H. C. Chambers, the chosen architects, designed the central library that remains so familiar to residents today.

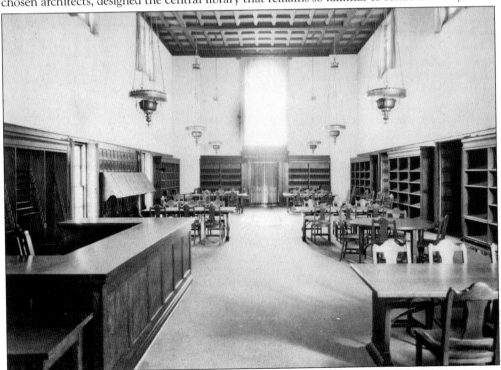

The public library had played a significant role in the city's life since the early 1880s, so it was fittingly an essential element of the 1920s movement to create a new civic center. The library was the first of the district's new buildings to be completed, opening to the public in February 1927. This photograph was taken shortly before the opening. (Photograph by Harold A. Parker.)

A model poses in the archway of the Pasadena Library, with city hall visible in the background. Both the library and city hall emerged from the City Beautiful movement and from Pasadena's organized effort to create a new civic center. City hall was at the center of the district, while the library anchored it on the north.

The buildings on the north side of East Colorado Street, pictured in 1929, give a sense of Pasadena's business district on the eve of the Depression. The storefront with the arches is the Pitzer and Warwick clothing store, boasting the slogan "For Lad and Dad." On the far right is Vroman's Bookstore, still thriving today. Pasadena's iconic city hall rises up in the background. (Photograph by the Hiller Studios.)

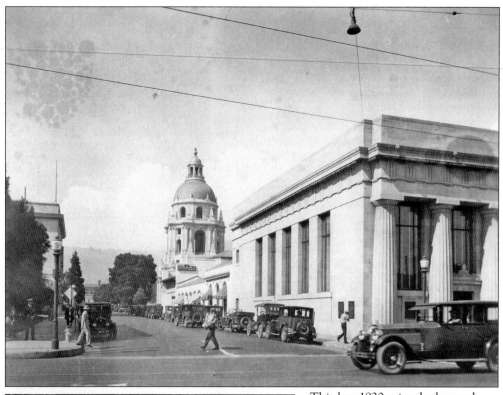

This late-1920s view looks north on Garfield Avenue from Colorado Street. Parked cars line the street, evidence of the importance that the automobile had now taken in Pasadena life. While residents could and did still get around the city by walking or taking streetcars, private automobiles were an increasingly popular alternative. (Photograph by George R. King.)

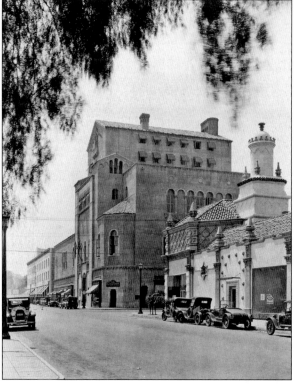

"It is not necessary to dwell upon the beautiful building, its spacious interiors and interesting motifs—an inspection will reveal their merits," reads a brochure for the Pasadena Athletic Club, located on the northwest corner of Green Street and Los Robles Avenue. Some of its offerings included volleyball, swimming, squash, and a tap room. Men were invited to regular "smokers" designed to "afford an evening of relaxation for the masculine element."

Alfred and Helen Davies sit on the curb with their children Clara, Helen, and Alfred, waiting for the 1929 Tournament of Roses parade to pass. Alfred Davies served as manager of the Marengo Market Company, situated at 145 South Marengo Avenue, a firm advertising it was "owned and operated by Pasadena home folks." The Davies family fit that category, with a house at 825 Belvidere Street.

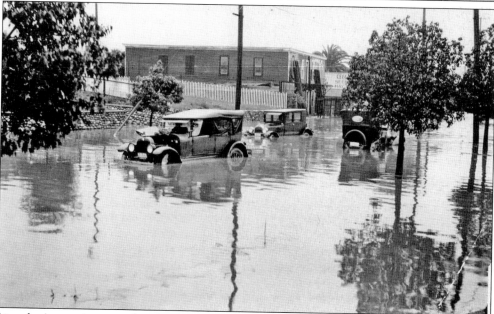

Lincoln Avenue is pictured in April 1926, following the flooding that still plagued the northwest quadrant of the city. Despite the floods, Pasadena's northwest, and Lincoln Avenue in particular, enjoyed a decade of growth during the 1920s. The Lincoln Avenue streetcar line connected the northwest to downtown Pasadena. Area residents also had easy access to the Rose Bowl and Brookside Park. Real estate prices rose as a result.

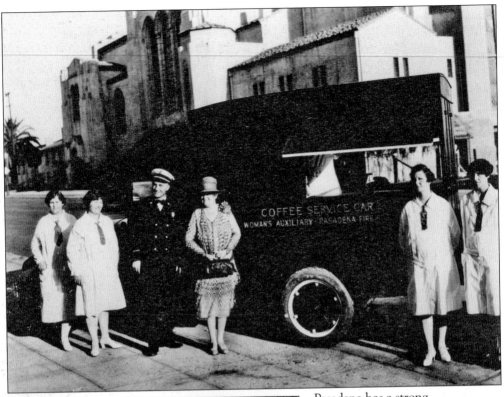

Pasadena has a strong philanthropic tradition. The city has long been home to many women's groups dedicated to making the city a better place. One such group was the Pasadena's Women's Auxiliary, which operated a coffee services car on behalf of the Pasadena Fire Department. Undoubtedly, the women running this service provided much comfort to many firemen as well as fellow citizens in need.

The building for Pasadena's American Legion Post No. 131, at 131 North Marengo Avenue, was designed by architects Marston and Maybury and built for a cost of $71,000. The American Legion was initially founded in 1919 with the intent of serving as a war veterans' service organization. (Photograph by George Haight.)

In August 1929, Pasadena resident Galusha Cole celebrated his 103rd birthday with great fanfare. The festivities started with an afternoon event at Memorial Park, where 1,000 people showed up for a ceremony that included comments by Cole and others. Many in the crowd then paraded, led by police on motorcycles, to Tournament Park for another ceremony as well as a picnic birthday supper. The 600 people at Tournament Park heard remarks from local and visiting notables and enjoyed pieces of a birthday cake baked by Fred Ash of the Modern Grocery and presented by the Indiana Colony. Here Cole poses with his 100-pound birthday cake while it was on display in the store. Cole was a dedicated member of the Knights Templar, hence the pyramid shape. The cake enjoyed by partygoers was not the one pictured, as there was an accident while workers attempted to transport this cake from store to park. Cole attributed his longevity to the 10 days he had spent subsisting solely on grasshoppers, though presumably the cake tasted better.

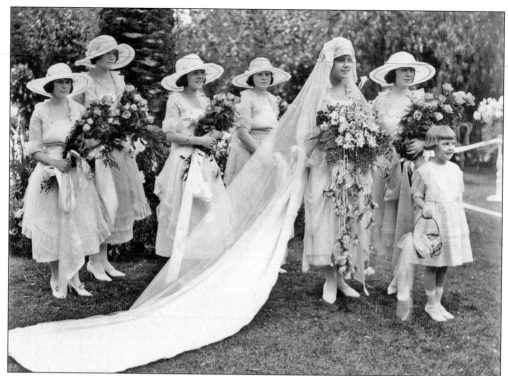

Margaret Mortenson, the daughter of a Midwestern lumber baron, married Ernest Crawford May in June 1920. Their wedding was held in the garden of her family's home, Mayfair, at 184 South Orange Grove Avenue. The couple later moved into the house themselves following the death of Margaret's father in 1924.

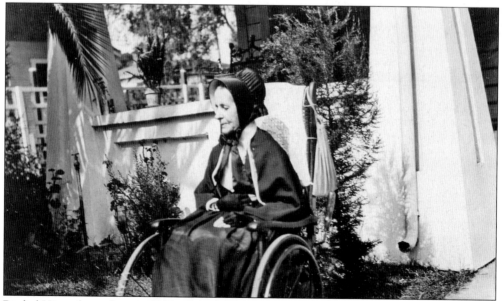

Rachel Hirst, shown here in 1929, was a Quaker preacher at the Pasadena Conservative Friends Meeting House, where her husband, Wilmer, served as the caretaker. Early Pasadena had a large and influential Quaker population consisting of many prominent citizens.

The Constance Hotel, located at Colorado Street and Mentor Avenue, is under construction in 1926. The reinforced concrete structure was to hold 164 "sumptuously furnished" guest rooms, each with its own bathroom, as well as a garage with space for 45 cars. The owner of the building was Constance V. Lewis Perry, a prominent local businesswoman and president of the Constance Investment Company. (Photograph by Hiller.)

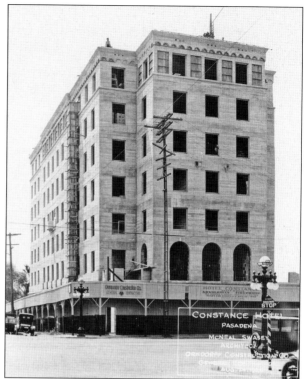

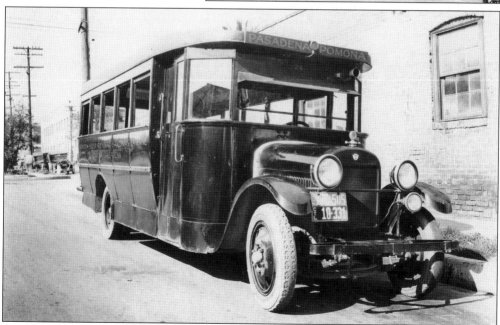

One of Pasadena's interurban bus lines is pictured in May 1926. Following an agreement between the City of Pasadena and Pacific Electric, all other bus competition was eliminated, a 6¢ bus fare established, and many train routes converted to bus routes. Pacific Electric also spent $500,000 to launch the bus system, creating a garage at Broadway (now Arroyo Parkway) and Bellevue Streets and buying 45 new buses.

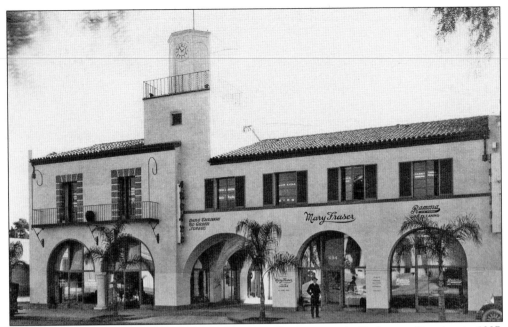

The Arcade Building's design was inspired by a similar structure in Budapest. Opening in 1927, the building was home to 27 stores and offices, including a wax flower shop, a tearoom, a candy shop, a jewelry store, and "moth proofers de luxe." The businesses were advertised as among the finest in the world, and several retailers had international branches.

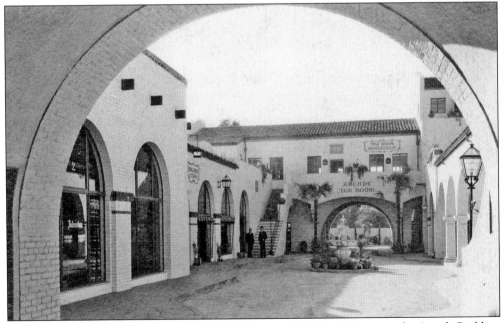

Situated on East Colorado Street between El Molino and Oak Knoll Avenues, the Arcade Building was one of many new developments growing up on East Colorado, far from the traditional core downtown. It employed a new design that accommodated shoppers and their automobiles; the driveway to the heavily advertised parking lot was dubbed "Luxury Lane." It was, as the *Pasadena Star News* reported, "another page in the city's development."

Six

THE ROUGH YEARS
1930–1940

The 1930s were dominated by the difficulties posed by the Great Depression. The city's industrial gains of the late 1920s were drastically reduced, with the number of industrial plants declining by half by 1933 and not starting to regain those numbers until later in the decade. It was a tough time for agriculture as well, as many local farmers were forced to sell their land.

With travel drastically down, Pasadena's traditional tourism- and service-based economy suffered major losses. Hotels and tourist attractions went out of business, eliminating hundreds of jobs. The Roosevelt Administration's New Deal programs helped provide some relief for the area. Construction of the Arroyo Seco Parkway, upgrades to utilities, and renovations to the Rose Bowl and Brookside Park were among the projects.

Pasadena's main downtown district continued to evolve. During the 1920s, the development of the civic center had moved downtown's center eastward; this trend picked up in intensity now that the major building projects of the 1920s had been completed.

The 1930s proved a good decade for the Tournament of Roses. During this time, it was first broadcast nationally—even internationally—bringing some of the exuberance of the floral-filled parade to radios across the country. This parade and football game coverage helped make Pasadena and its Tournament household names.

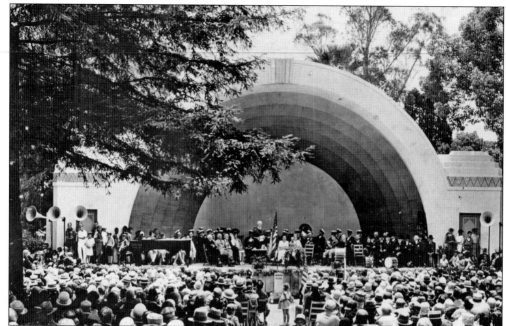

Taken in the early 1930s, this photograph captures the excitement of a concert at Pasadena's Memorial Park. Sunday afternoon concerts had become a city tradition by the late 1920s. The concerts continued to grow in popularity, leading to the decision to build a band shell. Following a city-sponsored design contest, a shell designed by Edward Mussa opened in 1930. The park's Gold Shell still hosts performances today.

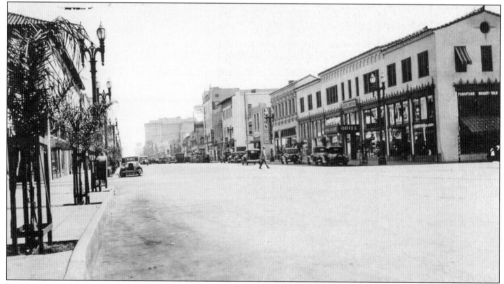

Looking east from Delacey Avenue, this view shows the south side of Colorado Street. The width of Colorado Street (now Boulevard) has changed over time and has been a much-discussed issue in Pasadena for most of its history. In 1884, the Pasadena and Valley Union reported that discussions were underway to widen the road, with other possible improvements including the planting of pepper trees, the addition of a cypress hedge, or the construction of a wire fence. The primary purpose of the hedge was to alleviate the near-constant dust problem.

This wooden building, photographed in the early 1930s while serving as a city storage shed, was Pasadena's first jail. It was built in the late 1880s in a lot adjoining Pasadena's then city hall, the former Central School on Colorado Street near Raymond. The jail was later moved to its city storage location on Glen Avenue.

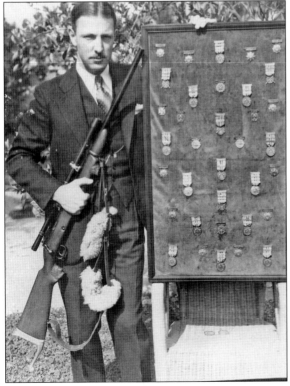

Maynard Turner was known for his work as a mortician and for his rifle shooting skills; he served as a rifle instructor during World War I and had won many local competitions. He poses here in 1931 with his prize ribbons. Turner was a funeral director at the Turner and Stevens Company, a long-established funeral home on the corner of Marengo Avenue and Holly Street.

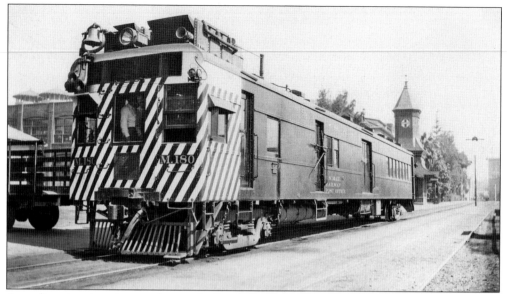

A gasoline-electric train car pulls into the Pasadena station in 1932, operating on a Los Angeles–San Bernardino route. The self-propelled passenger car, which also contained a place for mail and luggage, was built by the Pullman Company in 1929. (Photograph by M. A. Lowry.)

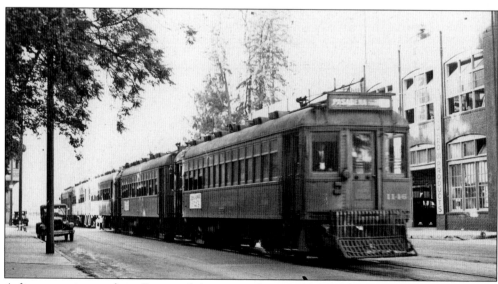

A five-car train travels on Raymond Avenue in August 1936. By the 1930s, buses were well on their way to replacing most of the Pacific Electric lines. Within five years of this photograph, Pacific Electric would sell its four local lines to a bus company, with the bulk of the metal track sold for scrap metal. (Pacific Electric Collection.)

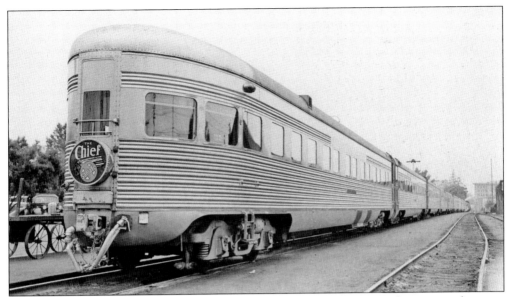

During the era of regular train travel, the Santa Fe *Chief* train transported passengers between Los Angeles and Chicago. Among other claims to fame, the *Chief* was the first train to offer air-conditioning. The *Chief* arrives at the Pasadena station in 1938. (Photograph by Allan Yovell.)

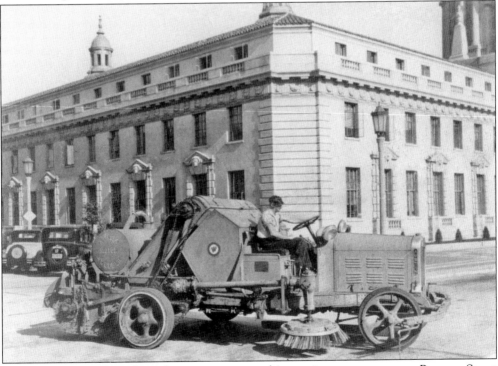

Herman Fox, one of Pasadena's longtime sweepers, drives a city street sweeper on Ramona Street and Garfield Avenue. Before the roads were paved, the city had employed men to spray them with water in an attempt to minimize early Pasadena's notorious dust. Even with the trucks, dust remained a problem, and most homes kept a duster outside the front door for visitors to use on their shoes before entering.

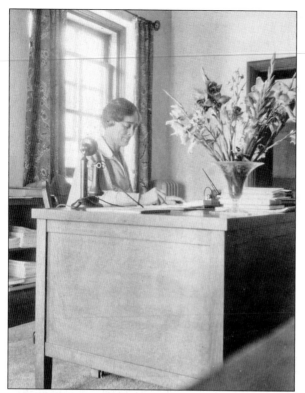

For many years, Jeannette Drake served as head librarian at the Pasadena Public Library. Among other successes, Drake instituted a "cardless" checkout system, making it easier for patrons to borrow books. Drake's innovations and hard work led to the rapid growth of both size and circulation of the collection. Here she works in her office in the mid-1930s.

Stratford House, seen at South Los Robles Avenue and Cordova Street in 1937, was host to meetings of the Shakespeare Club. Organized in 1888 as a literary and service club, the organization is allegedly the oldest women's club in Southern California. The name was chosen to honor the first author studied. Among other projects, the group maintained a public restroom in downtown Pasadena.

During the early years of Pasadena Junior College, life centered around three structures: the Horace Mann Building, the Jane Addams Building, and this one, the Louis Agassiz Building. Agassiz was a scientist who helped prove the existence of the Ice Age. There was no Pasadena connection; he was chosen as a symbol of higher learning and intellectual thought. The Agassiz Building is pictured in the early 1930s. (Photograph by Frederick W. Martin.)

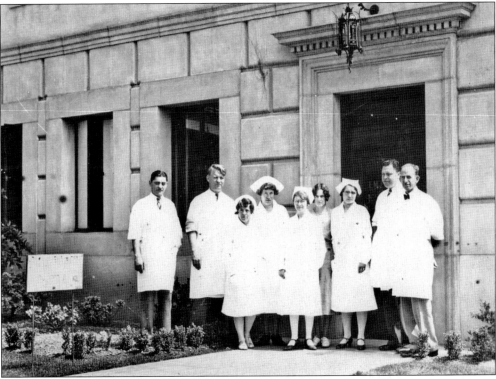

The Pasadena Emergency Hospital opened in the mid-1920s and treated nearly 4,000 people within its first year, all but 28 of them successfully. The hospital's medical staff, shown in 1930, handled medical emergencies ranging from heart attacks to agricultural accidents and automobile wrecks.

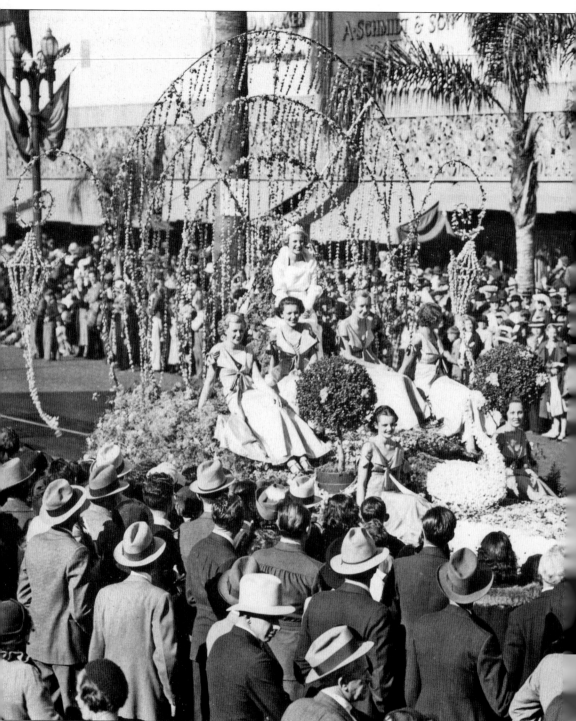

Tournament of Roses Queen Barbara Nichols rides down Colorado Street in a float in the 1936 parade. That year's parade set Tournament of Roses records, with crowds estimated at 1.5 million. Crowding along the route was a major safety and logistics issue, leading to the discussion of a possible extended route. One proposed path would have been 10 miles, requiring bands and

marching groups to instead be carried on flatbed trucks. The 1936 parade was also marked by a lack of network coverage; a controversy over distribution rights of the Stanford–Southern Methodist Rose Bowl Game led to five national news companies boycotting both the game and parade. (Photograph by Harold Parker.)

117

In 1934, the Pasadena YMCA celebrated its 50th anniversary of summer camps, and past and present leaders gathered to commemorate the occasion. George Braden (left), the director of the camp from 1901 through 1909, poses with the current director, Paul Somers. Somers later sent the snapshot to Braden with a personal note attached.

Pasadena's Pioneers met in June 1931 to reminisce about the past. The fraternal organization was formed by the early settlers of Pasadena and their offspring. From left to right are Jesse Vore, the second boy born in Pasadena; Helen Carter; Arthur Carter; Lulu Conger, the first girl born in Pasadena; and Harvey Watt, the first boy born in Pasadena.

The Pasadena chapter of the Grand Army of the Republic (GAR) organized in November 1885. Among other things, these Union veterans helped plan memorial ceremonies, decorate the graves of deceased veterans, and generally ensure that the principles for which they fought were not forgotten. The GAR comrades gathered at McKinley School on May 28, 1937, for Memorial Day, then commonly called Decoration Day.

Pasadena's first aid team, an official part of the fire department, answered the city's medical emergencies. This photograph was taken in 1930.

A member of the Pasadena Public Health Department posts a quarantine notice on the home belonging to an unlucky Pasadena resident. During the 1930s, several epidemics of polio swept across North America. With no vaccination available, families lived in fear of the dangers represented by the disease. Quarantines were one way in which public health officials attempted to stop its spread.

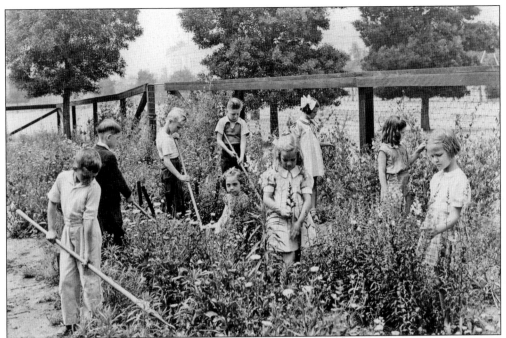

Gardening remained part of the standard classroom curriculum well into the 20th century. These Longfellow Elementary School students are hard at work during the 1936–1937 year. The school building is visible in the background.

Seismologist John Nordquist works in the Caltech Seismology Laboratory. The facility was established in 1921 to, in the words of Charles Richter, "investigate the occurrence of earthquakes in the Southern California region—to catalog them, determine their epicenters as well as their times of occurrence, and investigate their relationship to the known fault system." Nordquist and Richter collaborated on a project on at least one occasion.

Pedestrians walk up Walnut Street in the 1930s. The Santa Fe train tracks are visible in this photograph, which was taken near Library Park, a commons situated between North Raymond Avenue, North Broadway Avenue (now Arroyo Parkway), Holly Street, and Walnut Street.

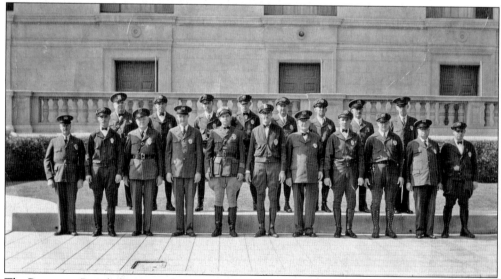

The Protective Patrol, shown in 1933, seems to have been a private security company headquartered in the Braley Building on South Raymond Avenue. The firm was managed by Carl Freeman, who was also the owner of a detective agency in the same office space as the Protective Patrol. He advertised that his office was open until midnight. (Photograph by Bennett-Kennedy.)

Pasadena's Sears, Roebuck, and Company was located at 532 East Colorado Street. In 1932, the store hours were from 9:00 a.m. to 5:30 p.m. on weekdays and from 9:00 a.m. to 9:00 p.m. on Saturday. Sears sold nearly everything one could want—from linoleum to sofas, trousers to electric refrigerators, washing machines to roofing materials, and building supplies to automobile accessories.

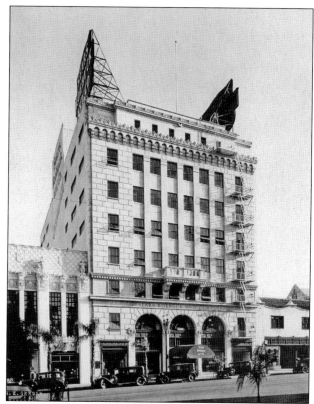

In August 1931, Pasadena welcomed its own branch of the county superior court with Judge Walter Wood (seated) presiding. The *Pasadena Star News* covered the opening ceremonies, later writing that the court and its new hall of justice marked "a significant milestone in Pasadena growth." This photograph was taken to commemorate the first case filed in the new court.

On January 6, 1931, officials gathered to ceremonially open a box placed in the cornerstone of the previous city hall. That cornerstone had been laid in 1902 during a Masonic ceremony presided over by Judge C. J. Willett. The contents of the opened box, pictured here, were later given to the Pasadena Historical Society, now the Pasadena Museum of History.

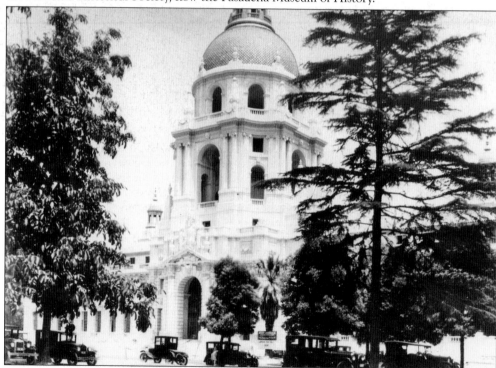

The Pasadena City Hall, seen in the early 1930s, was completed in 1927 at a cost of $1.3 million. More than one million boards of lumber went into its construction, along with more than 35,000 tons of rocks from the San Gabriel River. The building was the heart of the new civic center and the epitome of what many consider to be Pasadena's golden age.

Like any city, Pasadena's governing body has had its successes and failures over the years. Still, 1931 stands out as a year of exceptional problems. The members of the city's board of directors, shown here, had come to a total deadlock. A clash of opinions and personalities and an inability to compromise meant that nothing of significance was being accomplished. The angry citizens reacted by holding a recall election in December of that year. It was the largest vote to date recorded in a Pasadena city election, with 34 percent of registered voters coming to the polls despite the worst weather of the season. The result was a new slate of politicians, as well as a shift to a city manager system. Interestingly, many voters did not seem to have personal animosity toward the recalled individual directors. The *Pasadena Post* wrote, "The gentlemen who were recalled should not feel that this action was taken against them personally." Instead, the people of Pasadena were tired of an ineffective "daily dish of bickering and personalities." (Photograph by the Noel Studio.)

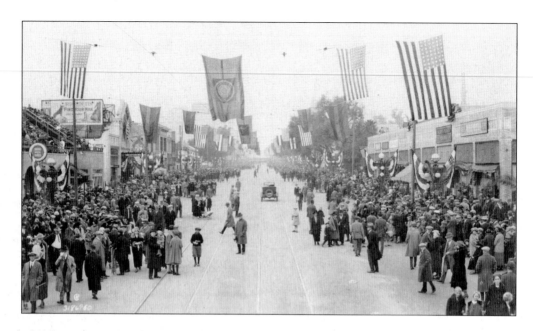

Crowds thronged the streets to view the 1939 Tournament of Roses parade—held on January 2 that year, as January 1 fell on a Sunday—eager to see the by-now legendary flower-covered floats and its celebrity participants. During the 1930s, the parade was broadcast live by radio across the nation, while newsreels showed it in theaters nationwide. The Tournament of Roses was famous, and the year 1939 was an important one in the parade's history: its 50th anniversary. To celebrate, officials procured Shirley Temple as grand marshal, the youngest in the history of the event. Above, people gathered along Colorado Street in preparation for the parade, while below, one of the parade's many bands marches along the Colorado Street route. (Photographs by the Aerograph Company.)

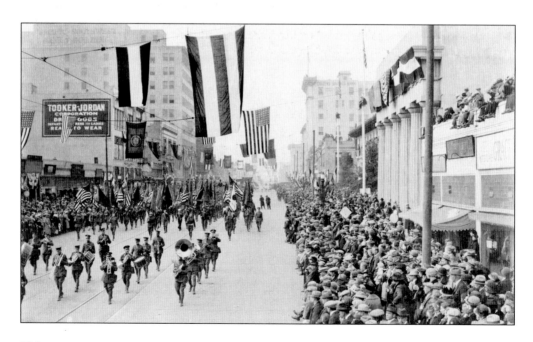

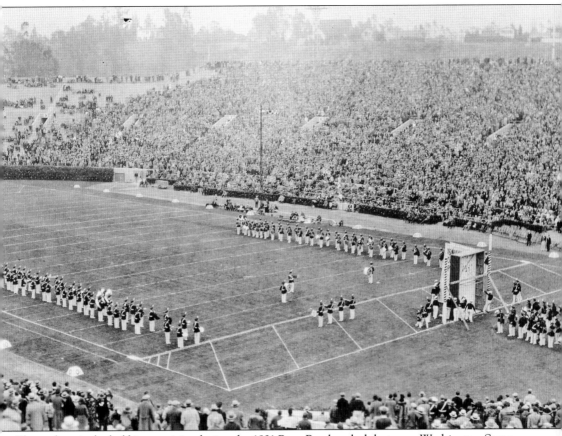

Shown here is the halftime activity during the 1931 Rose Bowl, a clash between Washington State and Alabama. This was the game that reportedly brought the "high five" to America—Alabama's "Five Yard" Fogerty got the ball 25 times, in each instance carrying it five yards. His teammates and fans started slapping palms and cheering "high five!" in their excitement. The excitement was well deserved: Alabama beat Washington State 24-0.

Across America, People are Discovering Something Wonderful. Their Heritage.

Arcadia Publishing is the leading local history publisher in the United States. With more than 4,000 titles in print and hundreds of new titles released every year, Arcadia has extensive specialized experience chronicling the history of communities and celebrating America's hidden stories, bringing to life the people, places, and events from the past. To discover the history of other communities across the nation, please visit:

www.arcadiapublishing.com

Customized search tools allow you to find regional history books about the town where you grew up, the cities where your friends and family live, the town where your parents met, or even that retirement spot you've been dreaming about.